.

CLEMSON TOUGH
GUTS AND GLORY UNDER DABO SWINNEY

LARRY WILLIAMS

FOREWORD BY TERRY DON PHILLIPS
PHOTOS BY ZACHARY HANBY

THE
History
PRESS

Published by The History Press
Charleston, SC
www.historypress.net

First published 2016

ISBN 978-1-5402-0353-3

Library of Congress Control Number: 2016930792

For the late Ken Burger, who said to write about people.

CONTENTS

FOREWORD

Over the years, many have asked, "Why Dabo?"

Candidly, I may have asked the same question had I been on the outside looking in when I selected him as Clemson's head football coach in 2008. No college head-coaching experience, not even a coordinator. It's well documented that, prior to his job coaching receivers at Clemson, he was selling real estate.

After Tommy Bowden's departure, Clemson offered an attractive head-coaching opportunity, and there was very strong interest in the job. I engaged a search consultant to assist me in gathering information on candidates and set up interviews at various locations nationally. Specifically, five coaches were interviewed in person while others were interviewed by phone. All candidates were either head coaches or coordinators. There was only one position-specific coach: Dabo.

Ironically, my decision to hire Dabo was greatly influenced decades earlier by a fellow football staff member when I was coaching defensive line at Virginia Tech. In the 1970s, I was on the same Hokies staff with a young offensive line coach named Danny Ford. Because we coached the fronts, we frequently worked against each other in drills, scrimmages and other situations. I came to admire and deeply respect how hard Danny worked his players, all the while creating and maintaining strong relationships with them. Danny had great rapport with his players in spite of the significant demands he placed on them.

This had a lasting effect on me. Great coaches are those who can demand and get tireless effort and commitment while building strong relationships. Not all coaches can do that.

Fast-forward three decades, and I was honored to be serving as athletics director at Clemson when I began to notice a young position coach at practice. Initially, I didn't know him from Adam's house cat. But I was drawn to how he coached the receivers and the toughness and work ethic he expected from them. It became obvious to me that, just like Coach Ford, Dabo genuinely cared for each and every player regardless of status. I began to observe his skill as a superb recruiter who was able to bring in players we couldn't sign before his arrival. And when given other duties, such as summer camps, he excelled.

For six seasons, I watched Dabo's passion to be a great coach and mentor to his players and knew he was special. Quite frankly, even in 2007 when Bowden was up for the Arkansas job, Dabo was certainly a part of my thinking as a possible replacement. Had the job opened up then, it would have been easier to hire him under those circumstances than with the turmoil of 2008 when we were 3-3 after entering the season with a Top 10 ranking.

Also ironic during this timeframe was Dabo's consideration of the head-coaching position at Alabama–Birmingham. Had he landed that job, I don't think I could have brought him back to Clemson with other head coaches having more experience regardless of how I felt about him. I do believe the Lord's looking out for Dabo. There's a reason he didn't get that job. Not that he couldn't do it, but he needed to be here to get this job.

As you know, Clemson University is an excellent institution with a strong football tradition, supported by many loyal alumni and friends. It has always been amazing to me that Clemson has been able to achieve at the highest level given its community setting and size. Having worked there for almost a decade, and being a resident of the area to this day, I better understand.

Of course, I struggled with the logic and conventional wisdom to hire one of the impressive candidates I was contemplating. By the South Carolina game, I was finally able to weigh how Dabo finished the season in his six weeks as interim, and I had talked to everyone I was seriously considering as head coach. No question that after the victory over South Carolina, I felt it the appropriate time to recommend Dabo as my choice to then president Jim Barker. I was convinced Dabo Swinney was a great fit for Clemson's unique character, values and passion—so convinced that I was willing to stake the final years of my athletics career on it.

Two years later, after a difficult season in 2010, Dabo has recalled how he thought I was going to release him when I came to his office after the loss to South Carolina. I knew it was going to be a very challenging off-season, and I wanted to reinforce to Dabo how I'd felt from the beginning to that point. Though it was only his second year, he had been elevated out of a program perceived to be very average, but I didn't perceive Dabo as being average. It was going to be tough—and it was.

It's again important to acknowledge President Barker's involvement as well. His strong support was greatly appreciated and a key endorsement of the decision and steadfastness.

Since my retirement, I've continued to watch Dabo remain the same as far as who he is. He's made good hires that fit his philosophy and style. He's a good leader of his staff with his fire and energy that create a sense of urgency and high expectations as to how they approach things. Those expectations come from the top.

It doesn't surprise me that he's become one of the nation's best coaches so quickly, though I can't say that I saw the No. 1 ranking so soon as part of that. I expected Dabo to be in the national hunt immediately and am extremely pleased that after the trying 2010 off-season, we won the ACC in 2011 for the first time in two decades. That was a significant first step.

So, why Dabo? Just ask his players.

—Terry Don Phillips

ACKNOWLEDGEMENTS

Dad, I don't know if Clemson can beat Alabama. They have Derrick Henry, and he won the Heisman Trophy. And they just won 38–0."

This came from my eight-year-old daughter over the phone as I made the trip home from Florida a day after Clemson's 37–17 thrashing of Oklahoma—and, yes, after Alabama's complete destruction of Michigan State in the Cotton Bowl. It was a bit stunning to hear because, prior to the 2015 season, neither of my daughters (the other is six) had shown much interest in the endeavor that captivates just about everyone else in this small but football-crazy college town.

I've been writing about college football for a living since 1998 and writing about Clemson football since 2004. Following this team's rise last season ranks atop the list of coolest stories I've covered, and it's really not even close. A big part of that is living in the community that's at the center of it all. You know the coaches and players, but you also know a lot of the people and families on the sprawling periphery of this massive operation. You go to church with some of them, you know their children and you see them in your daily life. You know how much their lives and livelihoods depend on the fortunes of this football program, and you know how much stress a lot of them are under when times aren't so good. So to see them just positively giddy during the special moments of 2015 was a powerful thing.

Another element that makes this story more powerful than most is Dabo Swinney's willingness to just be himself. While many coaches out there put up a wall and employ a strategy of being as bland as possible while

speaking in public, Swinney has been the genuine article. He always has his guard down. Always.

This is important to a reporter covering a team on a regular basis because you need your subjects to be expansive and expressive and honest. Otherwise, it's going to make for some dull stories and a job that feels, well, like a job. It almost never feels like a job covering Swinney and his program because he's always saying something interesting or revealing. And for those of us who enjoy telling interesting stories about his players and coaches, Swinney creates an environment that is conducive to that.

So without all this, what you are about to read probably doesn't get written. Much of this book is the product of what I observed and reported in the course of my day (and night) job of covering the Tigers for Tigerillustrated. com. It's the product of long conversations with Swinney after practice and longer press conferences on Tuesdays and Saturdays during the season. The first acknowledgement, then, should go to the head coach for just being who he is for all the world to see.

Thank you to former athletics director Terry Don Phillips, the man who made the bold and outside-the-box move to promote Swinney back in October 2008. Phillips hasn't been heard from much since he retired in 2012, but the more Swinney wins, the more brilliant this hire looks. Phillips seemed almost shocked when I asked him to write the foreword to the book. In my mind, there's no better person for that task.

Thank you to Jeff Scott, Tony Elliott and Brent Venables for giving their time to help me learn more about this crazy game and the details behind it. Thanks to the players who had the patience and willingness to open up. Thanks to Clemson's communications staff, including Joe Galbraith and Tim Bourret.

Thank you to friend Ron Morris for taking the time to sift through the manuscript with a fine-tooth comb and offer excellent advice while also catching a few typos. Ron has also been a great cheerleader for this idea from the start, and that emotional support has been important.

Thank you to photographer Zachary Hanby for his willingness—even eagerness—to allow a bunch of his excellent photos to run in this book. If you like what you see and would like to see more, shoot him an e-mail at Zachary@zachphoto.net.

Thank you to my boss, Cris Ard, for giving his blessings for me to divide my time between this and my full-time job. He would have been fully within his right to be apprehensive about this undertaking during such a busy time for our site, but he didn't blink when he said to go for it.

Thank you to my wife for her invaluable perspective, guidance and support through this whole process. She doesn't know anything about football, but she does about writing and storytelling. This would be a lesser book without her constructive criticism.

Thank you to Chad Rhoad and everyone at The History Press for jumping on board with this idea. When a season ends on January 11 and you plan to have a book about the season on shelves in February, it is not easy to pull off.

Thank you to my new friend Don for the lift home after the national championship.

We'll close with another personal anecdote, this one involving my six-year-old daughter. Until one Friday morning this past fall, she'd never shown anything resembling interest in the fortunes of Clemson football. She hopped out of bed singing the Clemson fight song ("C-L-E-M..."). Stunned, I asked her where she learned it. She said the team would visit her school that day, a ritual under Swinney that takes place once a year as the team departs for a road game.

She then proceeded to dress herself in Clemson garb. I thought Dabo would get a kick out of it, so I snapped a picture and texted it to him while informing him that this team had pulled off the remarkable feat of making my previously uninterested daughter interested in Clemson football. He immediately responded, "I love that. Will look for her." Now the last time

he'd seen her was years before, when she was a baby. So there's no way he'd have recognized her beyond the photo I sent him that day.

Sure enough, when he arrived at the school in the long line of players and coaches, he immediately spotted her and walked over to give her a hug and tell her he heard what she'd been singing at home hours earlier. An athletics department photographer was with the team and just happened to snap a photo of the interaction.

It was a cool moment that illustrated just how much this head coach is able to connect with people on a personal level. He is really a man of the people, an exalted figure who never behaves in an exalted manner. It makes him a good bit different from most multimillionaire coaches who build layers of insulation around themselves.

So a good story becomes a great one largely because the head coach isn't afraid to just be himself. I hope these pages do the story justice.

INTRODUCTION

From the middle of October to late November 2008, most people who encountered Dabo Swinney wanted to know how nerve-wracking it must have been to suddenly possess the keys to a major college football program. Six games into a failed season that began with immense promise, things didn't work out with Tommy Bowden, and he was gone after nine-plus seasons. The athletics director, Terry Don Phillips, shocked almost everyone, including Swinney himself, by telling this thirty-eight-year-old receivers coach he was the guy.

So Swinney had a six-game audition to win the job, six weeks to orchestrate some sort of change for the better after ugly losses to Alabama, Maryland and Wake Forest. It was the mother of all opportunities but also the mother of all challenges, which presumably imposed an immense amount of pressure on the man who was considered a long shot to get the gig.

Presumably.

"This is fun," he said in November of that season. "Man, this has been a blast. An absolute blast. I'll be fine no matter what."

At the time, Swinney had sat down for a lengthy interview with this writer to discuss his life story. Eleven months earlier, as Clemson prepared for a meeting with Auburn in the Chick-fil-A Bowl, Swinney shared some insight into his tumultuous upbringing during a casual, off-the-record conversation in a lounge of the Marriott Marquis in Atlanta. Now, as the 2008 regular season wound down, the story was more pertinent. It needed to be told. So William Christopher Swinney told it.

"I guess some people look at me and they see me with a calmness in the midst of a storm, and that's where that comes from," he said then. "It's because I've lived in that my whole life."

Shifting to the present, people sometimes wonder why Swinney pays so much attention to people on the outside who say his team can't do something. At regular intervals throughout the 2015 season, he brought up various slights that came from the media along the way. If it wasn't preseason skepticism about his inexperienced offensive line, it was preseason questions about his quarterback's ability to stay healthy after an injury-prone 2014. If it wasn't a former Notre Dame star predicting a "lugubrious" mood from Clemson players and fans for a rain-soaked showdown with the Irish, it was an ESPN reporter who dared use the term "Clemsoning" in a question for a story about how much the Tigers had done to flush the derisive moniker. Even after a convincing victory over Oklahoma in the College Football Playoff semifinal, after spending more than three weeks hearing that the Sooners were the favorite, Swinney told a national television audience that the only people who believed in his team were the team members themselves.

Step back and consider the context of Swinney's life, and it makes perfect sense that he uses what people say about what his team can't do to fuel the Tigers' motivational fire. Because for basically his entire life, he has been told that he can't do something. And darned if he hasn't overcome the odds and done it, every step of the way.

If you thumb to Swinney's biographical information in the team's media guide and rely on that alone to inform your view of him, his life seems blessed with an inordinate amount of right-place, right-time good fortune. He grew up in the suburbs of Birmingham, Alabama; fulfilled a childhood dream by walking on at Alabama; and later earned a scholarship for the Crimson Tide. He closed a storybook career by winning a national title under Gene Stallings. He then joined the team as a graduate assistant before becoming a full-time coach at the age of twenty-six. He married his high school sweetheart, Kathleen; has three healthy boys; and after five years under Bowden at Clemson he had the head job fall into his lap.

If you spend some time looking beneath the surface, though, you find a life that has been far from charmed. Swinney remembers climbing from his bedroom window and onto the roof as a child, trying to escape the venom and violence that accompanied his father's heavy drinking. He remembers going without lunch money as a twelve-year-old and sleeping on the floor of a friend's house as a senior in high school. He can remember sharing

a bedroom with his mother for much of his time at college in Tuscaloosa because she had nowhere else to go. He remembers spending weekends cleaning gutters to make money.

"When I see these guys, I see more than football players," Swinney said during that conversation in 2008. "I see a lot of myself in a lot of these guys. Lost kids trying to find their way. Scared. Don't know what the future holds. Problems at home. Financial problems. Whatever it is."

The wonder and innocence of childhood veered into harsh reality starting at age eight, when Swinney began to notice the effects of his father's boozing. Swinney was the youngest of three boys growing up in Pelham, Alabama. "I started seeing things that kids shouldn't see," he said. "There were times where he'd be gone and wouldn't come home and I didn't know why, and my mom would say this or that. There would be big fights and arguments, police called to the house, windows broken. I can remember praying to God to keep my family together and make things OK and protect my mom and my dad. My dad was a great dad. But when he would drink, it was not a good thing."

When Swinney was fourteen, his father's appliance business began to flounder, and the family lost the home they had lived in for ten years. The slow deterioration culminated in his parents' divorce when he was in the eleventh grade. He remembers sitting in the field house at Pelham High School, "crying like a baby" after he heard the news. To that point, he'd tried to keep everything from his friends. Tried to ignore the problems while painting his family as happy, sober, normal. Swinney was playing three sports and was part of the honor society despite all this, but the news of the divorce shook him. He and his mother moved out and began renting a condo, but not for long. Her job at the mall couldn't pay the bills, and an eviction notice was nailed to the front door after just three months. So they moved in with one of Swinney's high school buddies. Mom slept upstairs with his friend's mother and sister. Swinney slept downstairs on the floor, using an egg crate mattress he'd stash under the sofa every morning before leaving for school.

He wouldn't have been able to get through any of this without his relationship with Christ. He remembers the day he was saved (February 3, 1986), remembers what he wrote in his Bible that day ("I dedicate my life to the Lord. My life will never be the same.") He credits a youth football coach, Stewart Wiley, with facilitating that life-changing event. Wiley began a Fellowship of Christian Athletes chapter at Pelham High, and Swinney's revelation came at an FCA function there.

Swinney began dating Kathleen during his junior year. They'd met in first grade, began "going together" in middle school, broke up, but remained best friends through everything. He attended Alabama with the aid of Pell Grants and student loans, planning to become a pediatrician. He thought his football days were over until a Saturday that first fall in Tuscaloosa, sitting in the stands of Bryant-Denny Stadium and feeling the tug. His beloved Crimson Tide was three games into the season, and receivers were dropping balls left and right. He turned to Kath and said, "I can do that. I know I'm good enough to play."

Swinney arranged a meeting with Alabama's staff and told them he wanted to be a walk-on. He was just 165 pounds. The coaches were skeptical, but they told him to show up with forty-seven other walk-on aspirants. He spent the rest of the fall in the weight room, arriving at 5:30 in the morning three days a week. Two of the forty-seven made the cut for spring practice. Swinney was one of them. Simply being on the team was a remarkable accomplishment, and he worked himself into the rotation in 1989 as a receiver.

"That was the thrill of my life right there," he said. "A lot of people were telling me not to do it, that I wasn't good enough."

Swinney needed money, so on weekends he'd pack up a blower and make the forty-five-minute drive from Tuscaloosa to Birmingham and go door to door asking people in upscale neighborhoods if they needed their gutters cleaned. Sometimes he'd even do this on Saturdays after home games.

After the 1989 season, Coach Bill Curry was forced out after going 10-2 and winning the SEC title. Also gone was Bowden, a receivers coach who became close with Swinney and, thirteen years later, would hire him as receivers coach at Clemson. In came Stallings, and Swinney had to prove himself all over again. The new receivers coach, Woody McCorvey, ignored him and didn't bother playing him in the spring game. The personal storms in Swinney's life continued to rage. In the summer of 1990, his mother moved to Tuscaloosa and into the apartment he shared with a friend. From then until graduation, mother and son occupied the same room—even the same bed. Every Monday night, Carol McIntosh cooked chicken and dumplings for Swinney and a group of his teammates. Every weekday morning at five o'clock, she'd rise and make the trip to Birmingham and work all day before heading back to Tuscaloosa. Carol spent most of her childhood dealing with the devastating effects of polio and scoliosis, living in the Birmingham Crippled Children's Hospital for eleven years. Now she had nothing after the deterioration of her twenty-five-year marriage.

The situation under the new coaching regime presented a rare moment of pessimism in Swinney's life. He didn't think he'd make it under the new staff, and he even entertained thoughts of transferring. The Crimson Tide struggled in Stallings's first year, starting 0-3. At 3-4 after a home loss to Penn State, Alabama needed someone to catch the ball to revive a stagnant offense. Laboring in his standard role on the scout team the following week, Swinney was stunned to hear McCorvey yelling his name from the other side of the field. The coach told him he'd give him a chance at that practice, and if he did well he'd play the next game at Mississippi State. The feeling he experienced at that moment was remarkably and eerily similar to his reaction eighteen years later when Phillips told him he was giving him a chance at the Clemson job.

"You're going about your business," he said in 2008, "and the next thing you know your world is turned upside-down."

Swinney played three years for the Crimson Tide, lettering and earning a scholarship. Alabama went 11-1 in 1991 and won a national title in 1992, upsetting heavy favorite Miami 34–13 in the Sugar Bowl. In the basement of the home in Clemson he built and has lived in since arriving in 2003, mementos from his college career are placed throughout. Included is the official travel roster for that game at Mississippi State in 1990, plus the game ball he swiped from a referee on the glorious 1993 night in New Orleans after Alabama stunned the Hurricanes. He became the first person in his family to graduate college—"parents, grandparents, great-grandparents, everyone"—and he says his education has helped him make a difference in the lives of others.

Even with his degree in hand, Swinney kept cleaning gutters in the posh Birmingham neighborhoods whenever he had the chance. One of his customers offered him a job he didn't think he could turn down: thirty grand a year, company car, a chance at something he'd rarely experienced—a normal, stable life. But just before his first day on the job, he received a call from Stallings. There was a graduate assistant spot open on the staff, and Swinney took it. The next two and a half years were the most difficult of his life as he grinded on the Crimson Tide's staff while trying to prove himself, coupled with pursuing his MBA. The day after he received his master's in business administration, he was back on the rooftops of Birmingham cleaning gutters.

In February 1996, Swinney was twenty-six and looking for a full-time job. He thought Alabama was out of the question because Alabama never hired full-time coaches at that age. Stallings had reshuffled his staff

and had an opening, but Swinney figured his odds of landing it were almost impossible. Then Stallings called him to his office and offered him an opportunity to coach receivers, telling him one of the problems in the coaching industry was that no one was willing to give a young guy a chance.

Mike DuBose took over the Crimson Tide a year later after Stallings retired, and Swinney remained on the staff. He coached four more years but wasn't retained when DuBose was fired amid losses and scrutiny from the NCAA. He tried to get a job at Notre Dame as receivers coach when Urban Meyer left the Irish to become head coach at Bowling Green. Bob Davie, Notre Dame's coach at the time, wasn't interested. Nor were an assortment of coaches Swinney wrote letters to expressing interest in jobs. Swinney was completely ignored by a number of them, and he's never forgotten that experience as he's made a point to return every piece of correspondence from aspiring coaches with a signed letter.

Dennis Franchione was lured from Texas Christian University to take the Alabama job, and Swinney had hope of being retained under the new regime. Franchione went in another direction, and Swinney had to pack up his office as the last remaining coach from DuBose's staff after thirteen years as a player and coach at Alabama.

Swinney figured he'd take a month or two off and then catch on with another team, but another opportunity came forth when he received a phone call. On the other end was Rich Wingo, who served as Alabama's strength coach under Stallings. Wingo had become president of a major development company in Birmingham and wanted Swinney to join him and start selling commercial real estate. He began at AIG Baker in April 2001 at the age of thirty-one and was instantly humbled as he put on a dress shirt, grabbed a briefcase and entered another world.

"It was difficult," he said. "I go from coaching Alabama to not even knowing how to work the fax machine. I didn't know anything."

When Swinney left for work that first day, his wife stood in the driveway and cried. A few nights before, the mother of one of Swinney's former players had called to say how much she and her son missed him.

"It was a difficult day," she said. "Tears were just rolling down my face and I was like, 'Oh my gosh. I feel like I'm sending my child off to boarding school or something.' For what we had been through, it made me sad because I knew it wasn't really his dream. It was a great job. He was making more money than he was in coaching. But it really is not about the money. It didn't bring fulfillment for him professionally."

He learned quickly and flourished in his new profession as a shopping center leasing agent. He made good money, enough to later begin building his family's 6,400-square-foot dream home in southeast Birmingham. By that time, he and his wife had two boys. But not even parenthood came easy; Kathleen endured two miscarriages, one at fourteen weeks and the other at ten weeks, before giving birth to their first child in 1998.

In Tuscaloosa, Franchione coached just two seasons before bolting for Texas A&M. As the search for the new coach reached its conclusion, Swinney received a phone call from Alabama athletics director Mal Moore. He wanted to know if Swinney was interested in returning to coaching, and Swinney was. The new coach was going to be Washington State's Mike Price, and Price was interested in hiring Swinney to coach tight ends. The deal was basically done before Price left to coach his old team one last time in the Rose Bowl. Soon thereafter, Price called Swinney to tell him he'd changed his mind and decided to go with a more experienced assistant. He went with Sparky Woods, a coaching veteran.

"I couldn't believe it," Swinney said. "I mean, I had everything in my favor. I had already met with [Price] and talked to him. So that was disappointing. When that door closed, I was like, 'Gah-lee man. I just don't know if it's meant to be.'"

Soon thereafter, Swinney received a call from Bowden at Clemson. The Tigers' fifth-year head coach had a vacancy on his staff and wanted to know if Swinney was interested. It was a questionable move for both parties: Bowden was criticized for going after a coach who had been out of the coaching profession for two years, and Swinney's close friends told him it would be a mistake to join a staff that had just suffered a 55–15 pummeling by Texas Tech in the Tangerine Bowl. The Tigers had compiled a 14-11 overall record and an 8-8 ACC mark the previous two years. Athletics director Terry Don Phillips was in his first year on the job after leaving Oklahoma State. The circumstances were ominous and ripe for a short stay in Clemson. Swinney jumped at the chance anyway. His wife pregnant with their third child, he took a pay cut and walked away from a successful career selling real estate. He had to get back in the game.

"The two falls before that when Dabo wasn't coaching, we didn't even attend the Alabama games," his wife said. "We would watch them at home, but it was difficult for him because he's sitting there saying, 'I have all this knowledge of football and organization and players, and it's being wasted.' He knew he could help them. He longed for that. It was difficult because I knew that's what he wanted to do."

He was back in his element at Clemson, back doing what he does best, selling his vision to prospects in May 2003, when he learned that Price's tenure at Alabama was over. Price was fired after revelations surfaced that he was seen in a strip club during a trip to Florida for a golf tournament. Price's hotel room was charged about $1,000 by an unknown woman staying in his room, and this came soon after Price was reprimanded by Alabama for drinking in Tuscaloosa-area bars late in the night. Not long after confronting the disappointment of Price telling him he'd chosen someone else to coach his tight ends, Swinney knew he'd probably be out of a job had he gone to Tuscaloosa. He was right where he needed to be at Clemson, even if he was working for a coach who was on shaky ground.

"I'm just like, 'Thank you, God,'" he said. "Because I'd have been right in the middle of that. I was so thankful that I didn't get the job."

Swinney's tenure as a Clemson assistant was an exhausting roller coaster ride all by itself. In his first game as a coach, he stood on the sweltering sideline at Death Valley and watched the Tigers get ripped apart by Georgia 30–0. By late October, they had some momentum and a 5-3 record heading into a game at Wake Forest, but the Deacons dealt them a 45–17 shellacking that produced rampant speculation of Bowden's firing. Seven days later, they smoked No. 3 Florida State 26–10 to spark a dramatic late-season turnaround and a nine-win record that earned Bowden a contract extension.

The next year started with a miserable four losses in the first five games, including blowouts at Texas A&M, Florida State and Virginia. The Tigers pulled it together over the second half of the season and produced a supposedly landmark triumph at Miami, only to lose at putrid Duke the next week.

A late-season surge in 2005 sparked visions of national prominence in 2006, and in February of that year, Swinney was the key figure in signing coveted recruit C.J. Spiller from the state of Florida when few people thought Clemson could pry such a prospect from the clutches of Florida and Florida State. Later that year, the supposed breakthrough came with an upset of Florida State in Tallahassee. A few weeks later, the Tigers slapped around Georgia Tech on national TV to vault into the Top 10. Five days later, they melted down at Virginia Tech to begin a late-season spiral that included home losses to Maryland and South Carolina.

In December, the Tigers were trying to turn their attention to a date with Kentucky in the Music City Bowl when West Virginia coach Rich Rodriguez approached Swinney with an opportunity to go back to Tuscaloosa.

Rodriguez was going to accept the Alabama job after Mike Shula's firing, and Swinney agreed to join his offensive staff. He had spent four productive years at Clemson, and now it was time to go back home.

"I'd just thought about it through the week, and I was going to do it," Swinney said. "I'd made up my mind that this was the right thing."

Rodriguez then pulled out at the last minute, electing to remain at West Virginia. Alabama hired Nick Saban from the Miami Dolphins, and soon thereafter, Swinney had another opportunity to go back home to Alabama when Saban called to offer him a position as co–offensive coordinator and a major raise. Swinney had mixed feelings. He didn't know Saban personally. He had six recruits who'd committed and were going to sign at Clemson in February. He told Bowden he'd stay at Clemson if the school gave him a multi-year contract. Phillips signed off on the move, making Swinney assistant head coach and giving him a raise. Swinney called Saban and declined the offer, even with Bowden back on the hot seat after a bowl loss to Kentucky left the Tigers with four defeats in their last six games.

Also around this time, Swinney had his hopes up for the head-coaching job at Alabama–Birmingham. A week or so after Rodriguez decided to stay at West Virginia, Swinney put his name in for the UAB job. The athletics director called and told him to come down for an interview. But the next day, he learned the Blazers had hired Georgia assistant Neil Callaway.

"I had followed UAB for a long time," Swinney said. "I was like, 'You know what, we can get better. We can do that.' I was so excited about that. I was pumped. I was getting all my stuff ready. I was very, very interested in it, and I would have taken it. But I never even got to first base on that."

As it turned out, UAB wasn't much of a dream job after all. The administration refused to invest in facilities, and it ended up shutting down the program in December 2014.

Swinney often weaves this series of what-if moments into the testimony he gives at churches and other speaking engagements. The message: sometimes God knows better than you do.

"Sometimes you have to have faith in things you don't see," he said. "Coming to Clemson, I knew what I was supposed to do. Those were faith checks for me, and I tell coaches all the time to be patient because you never know. Be great at the job you're at. Bloom where you are planted."

When Swinney received the call from Bowden back in 2003, he was standing in the yard of the home his family was two weeks from moving into. At Clemson, he used the same blueprints to build a house identical to the one his family left in Birmingham. They still live there to this day.

Swinney's move to Clemson coincided with the repairing of his relationship with his father, Ervil. In 2004, one of the most fulfilling moments of Swinney's life came when he was able to move his father and stepmother into a home and out of the trailer they'd occupied for more than seventeen years. This came after "Big Erv," as he was called, remarried and promised to make things right with his family. In 2007, Ervil kicked alcohol and cigarettes.

"After mine and his mother's marriage broke up, we had some hard times there for a while," Ervil said in 2008 as his son auditioned for the job. "But he was just always an inspiration, always was. He's worked so hard to get to where he's gotten. He was definitely an influence on me getting sober, because I realized I wanted him to be as proud of me as I was of him. He was always there in support of me no matter what. I drank too much, things like that. And he was always begging me to quit. When your child does that, it always makes you look at which way you're going."

Ervil was able to chase away his demons, but he couldn't defeat cancer. On August 8, as Swinney was in the meat of fall camp preparing for the 2015 season, he was relaxing at his second home on Lake Keowee with family when a call came. Ervil had died at the age of seventy after battling lung cancer and other problems for years. Soon after visiting the heart doctor and telling everyone how good he felt, he stopped breathing. A little more than a year before, the family was stricken with grief when Kathleen's sister Lisa died of breast cancer.

After Ervil was diagnosed with cancer a second time in the spring of 2015, he moved to Clemson and lived in Swinney's basement while making regular trips to a hospital in Greenville for eight weeks of radiation and chemotherapy. Those times provided precious, unforgettable moments as father and son chatted through many a late night. Also there was brother Tracy, who moved to Clemson from Alabama in recent years after a career as a police officer.

"He struggled with his demons for a lot of years," Tracy said of Ervil. "Dabo stayed on him all the time. And at one time I had just almost washed my hands of him. I just didn't want to be around him and chose not to be around him. But Dabo, man, he kept hitting him and hitting him: 'Come on, Dad. You need to do this. You need to accept Christ in your life.' But still he would fail to those demons for so many years. But for the last fifteen years of his life, he did rededicate his life. He stopped drinking. He stopped smoking and was living a great life. He was really happy, and we all enjoyed being around him. When we talked him into doing his chemo treatments in

Dabo Swinney after his first victory as a coach, at Boston College in 2008.

Greenville and not in Birmingham, it was the best thing. Dad was living with Dabo downstairs. We were spending time with him. We were taking him out to dinner. We were taking him out to the lake, and we were taking him up to the hospital and just sitting in that chair and spending eight hours with him and talking. He'd nod off and go to sleep, then he'd wake back up and we'd talk about something else. It was a blessing. It was a blessing from God. He gave us that. He gave us those special months."

After his treatments were complete, Ervil went back to Alabama and was working at M&M Hardware. That's where he was most comfortable, surrounded by his best buddies and repairing washers and dryers. He was where he wanted to be, awaiting further testing to determine whether the cancer had gone. He stopped breathing while sitting in his chair at the hardware store. When Swinney returned to his team after the funeral, he told his players his father would have been yelling at him to get back to coaching: "Literally, as soon as they put him in the grave, 'All right, that's enough. Get yourself back to work. We have some football games to win.' That was Big Erv."

Sundays during the fall were the toughest as Swinney tried to move on without his father. Those were the days, immediately after his evening teleconference with reporters to wrap up the previous day's game, when

he'd call Ervil to catch up. Dabo and Tracy still haven't erased voicemails from their father that are stored on their cellphones.

Only after learning of the obstacles overcome in Swinney's personal life do you begin to understand how he views his professional existence as anything but life or death when it seems the weight of everything is on the shoulders of him and his team. He is the embodiment of his phrase "the fun is in the winning," dancing with his players in the locker room after victories and telling everyone that life will go on if the Tigers happen to lose a game. A few days before his team took on South Carolina last November, Swinney was asked how much easier his life had been over the previous year after Clemson ended the Gamecocks' five-game winning streak in the heated rivalry.

"My happiness is not defined by a football game," he said. "Unfortunately, some people's happiness is, but not mine. I don't live my life that way. Listen, it's been great every year, to be honest with you. When we've lost this game, I haven't walked around miserable the whole year. Now some people have. And some people were nicer to me this year than other years. But that's their problem."

Late on the night of November 27, 2010, Swinney had just left the locker room after a 29–7 loss to South Carolina at Death Valley. The Tigers started fast but couldn't last against an ascending Gamecocks program that would play for the Southeastern Conference championship. As the home team was muscled around in the second half, orange-clad fans booed and gnashed their teeth in response to Clemson's first back-to-back losses to South Carolina since 1970. This was not a good look for Swinney, whose team dropped to 6-6 and was headed for the nondescript Meineke Car Care Bowl in Charlotte. In 2009, his first full season as head coach, Swinney presided over an October and November revival from a 2-3 start as the Tigers won nine games and fell just short of their first ACC title since 1991. But patience was thin for a coach who'd been a member of the previous staff. Some fans wanted to fire Phillips, the man who made an unconventional hire the day after a 2008 victory over the Gamecocks.

As Swinney walked to his office, he was stopped by his wife, Kathleen. She told him Phillips was waiting inside and wanted to talk with him. Swinney's first thought: Well, it's been a fun two years. Phillips told Swinney to sit down. The coach thought it was over. "But I had a peace because I knew I was doing the best I could do. I had no regrets."

Swinney was shocked by what followed. Phillips told his coach the criticism would be intense over the next few weeks and over the entire off-

season. But he said he'd never been more convinced that Swinney was the right man for the job than at that very moment.

A month later, Clemson would lose to South Florida in the bowl game in Charlotte before tens of thousands of empty seats at Bank of America Stadium. The 6-7 final record, Clemson's first losing season in twelve years, put Swinney squarely on the hot seat in the eyes of many entering his third full season.

Swinney made changes to his staff and welcomed a celebrated recruiting class that February, and the wins started piling up. Clemson started 8-0 that first year and claimed the school's first ACC title in two decades. The team kept winning big, with 11 in 2012 and 2013 and 10 in 2014 and then the run all the way to the national title game in 2015. The dramatic twists and turns that marked Bowden's tenure with the program, and the first three years of Swinney's reign, were washed away by a remarkable run of consistency and stability that made Clemson a permanent fixture among college football's elite.

Nothing has been the same since those dark days in 2010—except maybe the head coach. He's the same guy he was back in 2008, when he was fighting like heck to wipe the interim tag from his title. Most people assumed it was the fight of his life, but he was actually having the time of his life.

"It takes toughness to believe, sometimes when there's doubt," Swinney said. "It takes toughness to stay the course."

15 FOR 15

Dabo Swinney sat down in a lounge on a mid-July evening at a posh golf club on the shores of Lake Keowee. This is the annual rite of summer that signals the unofficial end of vacation and the start of the coming football season as Swinney participates in his media golf outing.

Swinney had an air of comfort and confidence as he prepared for his seventh full season at Clemson. Each of the previous four seasons began with him facing plenty of questions about important players who had moved on. And each time, the Tigers responded with successful years. After compiling a 19-15 record in his first thirty-four games, Swinney had amassed a 42-11 record from 2011 to 2014. The record in his previous three seasons was 32-7, and each of those 7 losses came to teams that finished in the Top 10 of the Associated Press poll.

The 2014 season began with questions about how the prolific Tigers offense could replace Sammy Watkins, Tajh Boyd, Martavis Bryant and several other important players. The Tigers ended up leaning on a dominant defense to reach ten wins, overcoming injuries to star quarterback Deshaun Watson and several offensive linemen. That the Tigers could win with defense while rebuilding on offense was a testament to years of impressive recruiting and development on defense under Brent Venables, who arrived from Oklahoma in 2012 to replace Kevin Steele after the 70–33 Orange Bowl debacle against West Virginia.

The questions at the preseason golf outing are almost always shaped by the outside narratives that dominate college football coverage through

the off-season. So on this day, Swinney was repeatedly asked about the health of Watson.

Watson, last seen in 2014 engineering a spanking of South Carolina while dealing with a torn anterior cruciate ligament, had surgery on the knee soon thereafter. So as he sat out spring practice while recovering, it was natural to wonder whether the Tigers' star sophomore would be back to full strength by the start of the season. In the spring of 2014, he suffered a broken collarbone. And a broken hand against Louisville forced him to miss the better part of six games just when the offense was starting to hum. So now, the scribes and talking heads were asking Swinney if there was any concern that Watson might not be able to make it through an entire season. They were asking him if the offensive game plan might be altered, taking away the quarterback run threat to minimize the threat of injury to the Tigers' prized possession.

Swinney thought the questions were silly. He knew Watson's dual-threat abilities made this offense go. He knew Watson was one of the best players in the country, if not the best. He wasn't about to impose any schematic restrictions out of fear of losing him.

"You can't play this game tiptoeing around and worried about getting hurt," Swinney said. "If a guy gets hurt, you've got to have somebody else ready. Ohio State won the national championship with their third quarterback. So ain't nobody going to feel sorry for you if your guy gets hurt. We're not going to do things differently trying to put him in some type of bubble. We're going to play. That's just what we do."

In addition to the questions about Watson, people on the outside were skeptical of an offensive line that lost four starters. Less than a month earlier, when the coaches were in the middle of their vacations, senior left tackle Isaiah Battle left the team and entered the NFL's supplemental draft after a citation for marijuana possession. Battle's departure meant freshman Mitch Hyatt was going to be thrust into a prominent role. Hyatt had played well during the spring after enrolling early, but there was still plenty of reason to wonder how long it would take him to adjust to the college game because it just wasn't common for first-year freshman offensive linemen to come in and flourish right away. Inside the program, they believed Hyatt was capable of beating out Battle before Battle left, and everyone thought the freshman from the Atlanta suburbs was going to be a star in time. But it was impossible to predict how long that would take.

The defense was also dealing with the departure of a large number of important players from the 2014 group that staked a claim as the top unit

in college football. Eight of the top twelve tacklers were gone, including star defensive end Vic Beasley. Also departed was the rock in the middle of the line, Grady Jarrett, and star middle linebacker Stephone Anthony. The defense lost ten players from the line and linebacker groups, and it was assumed by many it would drop off significantly in 2015 as a result.

Chad Morris, the architect of an offense that put up points in bunches from 2011 to 2014, left for the head coaching job at Southern Methodist the previous December. Swinney promoted two coaches who had never regularly called plays, Tony Elliott and Jeff Scott, to serve as co-coordinators. So there was natural skepticism about the offense's ability to continue the success seen under Morris.

In addition, veteran kicker Ammon Lakip was indefinitely suspended after an off-season arrest for DUI and cocaine possession. Add in defensive end Ebenezer Ogundeko getting kicked off the team in May after an arrest for credit card fraud, and it wasn't a hunky-dory off-season for the Tigers. Swinney, forty-five, said a few missteps here and there didn't represent a team-wide trend.

> *There is no utopia. If there are people out there anywhere that think there is a program in the country with eighty to one hundred young people that won't have to deal with bad behavior or bad decision-making from time to time, that place doesn't exist. That's a unicorn. That just isn't reality. But it's the discipline and the consequences that determine the culture of your program. I don't worry about it. I know that from time to time someone is going to challenge the culture of your program, and you have to reinforce those things. Every situation is dealt with on an individual basis. I don't have any concern about the culture of our program at all. Because if guys get in trouble, they're going to be dealt with.*

Lakip's indefinite suspension left a hole at placekicker. The Tigers lost their punter, Bradley Pinion, when he elected to leave early for the NFL draft. The presence of forty freshmen on the roster was cause for concern. But Swinney offered a reminder that the Tigers' 2011 team had the same number of freshmen when Clemson broke through and claimed the ACC title for the first time in two decades. The head coach's big-picture belief: even with all the inexperience and youth, the Tigers were still going to be more talented than most of the teams they played. And they were going to be hard to beat as long as the gifted Watson was on the field. Swinney said:

I don't think we have many weak spots. We've got some inexperience, some growing up to do and a lot of coaching to do in some areas. But I don't think there's a particular spot on our team where we're inferior to our competition from a talent standpoint. But talent alone doesn't win. It's commitment. It's those guys' work ethic. It's those guys' willingness to do those things that they need to take their talent and be great with the talent. It's unselfishness. I mean there's just a lot of things that go into it from a team standpoint. But on paper? As I've said—I said it two years ago—we're built to make a run.

The events of the 2014 season produced a strong belief that the Tigers weren't far away. They went to Florida State and outplayed the Seminoles when almost no one thought they'd do so before losing 23–17 in overtime. They were outplaying Georgia Tech late in the season before Watson went down with a knee injury to turn the momentum in a 28–6 loss. They finally knocked off nemesis South Carolina in convincing fashion. And then they completely smashed Oklahoma in the Russell Athletic Bowl, 40–6, when even most Clemson fans thought they'd lose. The good vibes from that late December whipping continued into February, when Swinney and his staff signed yet another banner recruiting class that included Hyatt, receivers Deon Cain and Ray-Ray McCloud and defensive tackle Christian Wilkins.

A few days after the golf outing, the ACC media gathered in Pinehurst, North Carolina, and picked Clemson to win the conference. In addition, Watson was voted preseason player of the year. This was a notable development because Florida State had been the king of the conference since 2012. Clemson knocked off the Seminoles in 2011 on the way to the ACC title, but Jimbo Fisher's team proceeded to smack around the Tigers in 2012 and then again in Death Valley on the way to the 2013 BCS title. Florida State amassed a 39-3 record over a three-year period, and in 2014, the Seminoles advanced to the College Football Playoff before losing to Oregon in the semifinals. The catalyst behind Florida State's 2013 and 2014 dominance, Jameis Winston, had left early for the NFL. Now it was Watson's turn as the conference's glamour figure, and Clemson's as the ACC's glamour team. Clemson received eighty-four votes for the ACC title compared to forty-one for Florida State. Swinney told the media in Pinehurst that the vote might have been unanimous had Watson played a full season as a freshman instead of just eight games.

"He's beyond what you've seen. It's pretty easy to watch this kid play and say, 'Wow, this is a rare guy.' But he's only been in college a year.

What you really don't know is who he is. This is a special person. Great leader. One of the smartest players I've ever been around. I haven't been around many seniors with football IQ this kid possesses right now as a true sophomore."

Clearly, the Tigers' résumé in recent years had built credibility in the eyes of national media that once poked fun at Clemson's decision to promote a little-known receivers coach to head coach. Four consecutive seasons of ten wins or more, plus a twenty-seven-game winning streak over unranked foes, created benefit of the doubt in the face of off-season questions. Swinney was still trying to overcome Fisher and Florida State, but he nevertheless had some big-name skins on the wall, including Les Miles, Urban Meyer, Steve Spurrier and Bob Stoops.

Still, there weren't many people picking Clemson to land in the second College Football Playoff. The Tigers were sniffing the elite level, but they weren't there yet. At least that's what most folks on the outside thought. The Tigers were believed to be a year away, too young to win it all. Inside the program, there was a strong belief that the Tigers were as good as anyone out there.

When the team convened for the start of August camp, Swinney told his players to dream big. T-shirts were printed with the logo "15 for 15," an encapsulation of the goal to "make them print 15 tickets" by advancing to the ACC title game, the national semifinal and the national final. As much as some people wanted to focus on what Clemson didn't have or what might go wrong with an injury here or a missed field goal there, Swinney opted to highlight what the Tigers did have. The defense, for instance, welcomed back plenty of experience even though it lost so much from 2014. The defensive line returned several seasoned players, including ascending defensive end Shaq Lawson and tackle Carlos Watkins. Behind them were veteran linebackers Ben Boulware and B.J. Goodson. And behind them was a fast, talented, deep secondary.

"To the outside people who look at our roster and look at who the starters were last year, people don't really see Ben Boulware and B.J. Goodson as starters. But we do," Swinney said.

The strength of the 2014 defense wasn't just front-line talent. It was an extraordinary amount of depth that allowed Venables to substitute at will with very little drop-off to the second-stringers. A year later, Venables and Swinney entered the season confident in the starters but wondering about the inexperienced backups. Swinney said:

You just had such experienced depth last year. This year, I think we're talented and we're deep, but we're just inexperienced with our depth. That doesn't mean we can't be really good on defense. It just means that some young guys have to play well for us. They don't necessarily have to be starters for us. We're not in that situation. That's a whole different animal. And that's where I think we have to get lucky and keep that first group healthy. Whereas last year, an injury or two or three up front, I don't think it would have affected us. This year, all of a sudden you lose a couple of those veteran guys up front especially, it's a whole different deal. Because now it affects your ability as far as what you can call, what you can game plan for, your multiplicity... We're a little vulnerable in that regard in that we don't have a lot of room for early injuries.

During camp, the defense lost two important players when defensive back Korrin Wiggins suffered a torn ACL and D.J. Reader took a personal leave of absence. Wiggins was gone for the season, and Reader wasn't expected back until late September at the earliest as he worked through issues that put him in the coaches' dog house. During the off-season, Wiggins and Reader were two big reasons for optimism; the veterans had combined to play in sixty-three career games and 1,641 snaps. The subtraction of these two from the equation meant the defense had lost more than 6,000 career snaps from the 2014 group. Two weeks into camp, backup linebacker Korie Rogers left the team after redshirting as a first-year freshman in 2014. That created what Venables termed an "emergency" situation behind Boulware and Goodson at inside linebacker.

Despite all this, the defense remained defiant and almost offended at outside notions of a significant decline in 2015. At the start of camp, junior safety Jayron Kearse wondered why Clemson's attempt to replace key players was described as rebuilding when it would be called reloading for certain teams in certain other conferences.

"They ain't asking nobody else these questions," Kearse said. "They lose great players, they don't get asked these types of questions. It's just the territory I guess. We're in the ACC. We're Clemson. I guess we can't be as good as those guys."

Morris helped transform Clemson's identity over four years after Swinney hired him away from Tulsa in January 2011. Amid calls to hire a seasoned coordinator to replace Morris, Swinney said the quick move to promote Elliott and Scott was "the easiest decision I've ever made." In 2008, Scott was a graduate assistant when Swinney took over for Bowden.

Swinney promoted him to receivers coach, and later, Scott became a major figure in Clemson's recruiting machine. When he needed a running backs coach in 2011, Swinney bypassed more experienced options and chose Elliott. The two had a close relationship from Elliott's days as a walk-on receiver at Clemson in Swinney's first year at the school. Elliott and Scott had worked closely with Morris for four years and were given an increasing level of responsibility during that time. Instead of visiting other schools during the off-season to pick up new ideas, a practice that Morris made routine during his time at Clemson, Elliott and Scott looked inward and conducted a rigorous self-study of the previous four seasons. They determined that too much fluff had accumulated in the playbook, resulting in distraction when it came to execution during games. They lopped off about 30 percent of the playbook and placed the focus on their players mastering a smaller number of concepts.

After Morris left in December, Elliott and Scott condensed the playbook by necessity as they hurriedly prepared for the bowl game against Oklahoma. New quarterbacks coach Brandon Streeter came aboard at the same time, so going simpler made sense to help aid his transition. The offense's success in that game, with quarterback Cole Stoudt playing brilliantly after some pronounced late-season struggles, seemed to bring more confirmation that trimming the playbook was the long-term model.

"We just felt like we needed to get back to the basics," Scott said during spring practice. "We call it the Chick-fil-A method: they have great sales numbers, and what do they do? They sell chicken. That's all they do. They don't try to do everything. Other restaurants are doing different things with breakfast, lunch and dinner. They've got so many choices, so many things out there, that you can kind of get confused at the menu. We stressed that in the bowl game. We wanted to get back to the basics and get really good at what we do. So this was a spring cleaning, if you will."

Another move the staff made was giving Watson more authority to change plays at the line of scrimmage before the snap. He had an exceptional ability to read defenses and make the right decision based on what he saw. Veteran offensive lineman Eric Mac Lain marveled at some of the things Watson was doing in practice, comparing him to NFL legend Peyton Manning.

"Cole wasn't given the opportunity to do certain things like Deshaun has been. Cole was great at reading things too, but he just wasn't given the keys to the car as Deshaun has been given this year. When you watch the NFL, you don't see a lot of guys taking control like Peyton does. Deshaun has that ability. He can see so much, and it's such a great attribute for such a young guy."

The offensive staff spent the first couple weeks of August getting a long look at McCloud and Cain, the two freshman receivers from Florida who'd arrived over the summer. McCloud seemed comfortable from the first day, but it took longer for Cain to adjust to the speed of the college game. Swinney compared Cain to former Tigers star DeAndre "Nuk" Hopkins. Whereas Hopkins was the only playmaker the Tigers had at receiver when he arrived in 2010, the 2015 receiving corps was loaded with elite athletes. Cain spent camp with the third-stringers, playing behind Mike Williams and Trevion Thompson. Swinney said in August:

> *We've just got different people here than when Nuk came in. Nuk really wasn't a very good receiver as a freshman. He really had to buy in. He was weak. He had a lot to learn fundamentally, technically. He just had freaky ball skills. That's kind of what we've got with Deon Cain. He's got freaky ball skills. He's a little more polished, maybe, than Nuk was. But he's still raw. He's got to be willing to put the work in like Nuk did. Nuk got better and better and better, and by the end of the year, he was pretty good that freshman year even though he still wasn't very strong. Whereas Deon is bigger, stronger, he can run, he's got a good understanding…We've got to have him play. He's going to help us win this year, there's no question. He's not ready to be an every-down, complete player yet. But we don't need him to be. We just need him to know what to do when he's in there and make the plays he needs to make.*

Morris was back in his home state of Texas, undertaking the massive task of rebuilding SMU's tattered football program during August practices. During an interview with Sirius/XM Radio, he offered glowing reviews of the program he left:

> *Without a doubt, Clemson has an opportunity. I felt that when I took the job there. With the returning starters, the way we recruited, the sky is the limit. I think what you are seeing right now is Clemson is just now hitting their prime. They're just now hitting their peak, and they're going to be at a level to make a run for a while. It's all because of what Coach Swinney has done there.*

CHAPTER 2

"BRING YOUR OWN GUTS"

From the moment the 2015 schedule was released in late January, much of the focus was on the third game and not the first two. Comfortable wins at home over Wofford and Appalachian State were assumed, giving players and coaches a lot of time to think about a Thursday night visit to Louisville.

In 2014, the Tigers were lucky to get out of their own stadium with a 23–17 win over the Cardinals after Deshaun Watson left the game early with a broken hand. Clemson fans still remembered the nerve-jangling final moments after Louisville hit for a big pass to put the ball a few yards from the goal line, before the defense produced an unforgettable stop to unleash a delirious celebration at Death Valley after the sixth game.

Clemson was able to get past Wofford and Appalachian State with the anticipated ease, winning 49–10 over the Terriers and 41–10 over the Mountaineers. But the Tigers couldn't get through their first possession of the season without a major personnel loss and a scary sight. Mike Williams, the junior receiver who was likely headed for a breakout season as the Tigers' best wideout, collided with the base of the goalpost in the back of the end zone and suffered a fractured neck bone that ended his season less than four minutes after it began.

There was no panic among the staff after further examination revealed Williams would be out for an extended period. Co–offensive coordinator Jeff Scott said the Tigers still had plenty of weapons at receiver, and it was time for senior Charone Peake to elevate and become the impact player everyone thought he would be when he arrived at Clemson in 2011.

"We're going to be perfectly fine," Scott said two days after the opener. "I told my guys this morning, there's not going to be anybody in the country that's going to feel sorry for the Clemson wide receivers. We've got plenty of guys. There's no excuses. That's why you recruit a lot of guys, because injuries happen…Our guys are ready for it, and we prepared in fall camp. Mike was a guy that we knew was going to get a lot of balls. And when you get a lot of balls, you put yourself in more of a risk situation. So we've been preparing knowing that those guys have a tendency to get injured as the year goes on.

Though the trip to Papa John's Stadium was daunting, particularly given that it came just five days after the win over Appalachian State, Clemson had a scheduling advantage entering this matchup. Louisville, which had to replace a large number of players from a nine-win 2014 team, traveled to Atlanta to face Auburn in its opener in front of a decidedly partisan Tigers crowd at the Georgia Dome. After a draining game in which the Cardinals fell behind big early before battling back to lose 31–24, they returned home for a game against Houston and first-year coach Tom Herman. The Cougars were supremely motivated, having circled that game on the calendar all off-season, and they ended up handing Louisville a crushing 34–31 defeat to drop second-year coach Bobby Petrino to 0-2.

Clemson also had the benefit of keeping a significant part of its offensive playbook under wraps during the first two games. Watson, considered the nation's premier dual-threat quarterback, hadn't run much against Wofford and Appalachian State. That was by design, as the coaches tried to ease him in after a long off-season of rehab from ACL surgery but also as they tried to preserve the element of uncertainty in the ACC primetime showdown.

Many Clemson fans were thinking the Tigers would go to Louisville and administer a monster whipping on the Cardinals in dropping them to 0-3 for the first time since 1984. But Dabo Swinney and his staff knew it wouldn't be easy against a well-coached team that had been hearing about how bad it was in the days after the loss to Houston.

Anyone who watched the game or looked at the statistics sheet knew Clemson was the better team. The Tigers had 401 total yards to Louisville's 272. The Tigers out-rushed the Cardinals 202–19, led by a bruising 139 yards from Wayne Gallman on twenty-four carries. But strange things can happen, just as they did a year earlier when these teams got together and Clemson walked away feeling fortunate to win.

Clemson had to sweat out a 20–17 victory after failing to land the knockout punch in the first half, after giving up a one-hundred-yard kickoff return for

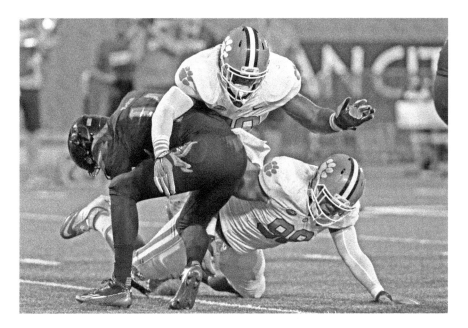

Shaq Lawson and Kevin Dodd with a tackle for loss at Louisville.

a touchdown in the fourth quarter to let the Cardinals back in it and after Watson missed tight end Jordan Leggett on a late third-down throw that might have sealed the game.

"We showed a lot of mental toughness—and a lot of stupidity too," Swinney said afterward. "We could have put that game away."

The positive of this game was that the Tigers were able to lean on their defense in a way that resembled 2014. Without Vic Beasley, Grady Jarrett, Corey Crawford, Stephone Anthony and a host of other high-impact players from the previous season, Clemson's defense used disruptive plays from the front four to keep the Cardinals scoreless after they reached Clemson territory on their final two possessions needing a field goal to tie it and a touchdown to go ahead.

The offense had to punt after a first-down run by Watson was overturned by replay. And the defense seemed to be reeling when Cardinals tight end Micky Crum found himself open over the middle for a twenty-three-yard gain to put Louisville at Clemson's thirty-seven-yard line.

Two plays later, quarterback Kyle Bolin tried to break outside of the pocket, but defensive end Kevin Dodd would not let him. Dodd ripped him down and to the turf, and as the clock ticked and ticked, Louisville had no

choice but to try for a prayer to the end zone that was tipped and intercepted by Jadar Johnson.

Dodd, a fourth-year junior, had been essentially anonymous until 2015. Entering the season, not many people on the outside were forecasting game-changing plays from No. 98, but he supplied a big one with the Cardinals threatening.

"There was no bigger sack than the one Kevin Dodd had," Swinney said.

Greg Huegel, the walk-on kicker who won the job in August and started during Ammon Lakip's three-game suspension, made kicks of thirty-six and twenty-seven yards in a pressure situation. Louisville converted just two of fourteen third downs. The Cardinals were a combined three-of-thirty-one on third downs in their 2014 and 2015 meetings with the Tigers.

"I love the fight," said defensive coordinator Brent Venables. "That was fun to watch, just watching them continue to battle. It was like a heavyweight slugfest out there. I loved watching the attitude and the toughness they showed."

Swinney offered some foreshadowing with his big-picture appraisal of the victory that improved Clemson to 3-0 with a showdown against Notre Dame up next: "You hate to say that you need that, but if you're going to be a great team then somewhere along the line you've got to be tested and show what's in your guts."

After an open week that gave the team its first rest since the start of camp, the Tigers turned their attention to the Irish. And if they weren't already enthused enough for this game, Notre Dame receiver Will Fuller pushed it to another level with a Tweet promising that the game would be "savage." The message was interpreted by Clemson as a warning that the Tigers were headed for a whipping in the primetime, nationally televised game on their home turf.

Junior safety Jayron Kearse was prepared to return Fuller's fire when he met with the media five days before the game. Kearse said Clemson's standard approach toward trash talk is not to start any wars of words. But if someone from another team pops off, it's on. Kearse said Fuller, regarded as one of the premier receivers in the game, was going to pay for his comment against the Tigers. Kearse said Florida State's Rashad Greene and South Carolina's Bruce Ellington were the best receivers he'd faced during his college career. He said Fuller looked like he ranked in that class on film. Emphasis on "on film."

We'll see what he can do Saturday. Those guys I mentioned had good games against us. It wasn't just off of film. If he can come out there and show us

ESPN's *College GameDay* on the set at Bowman Field before the Notre Dame game.

something Saturday, then we can consider him. But until then, he's not in there...They're headed for a rude awakening. They haven't faced nobody like us. We'll be the best team they play all year, hands-down. And they've never seen [an environment] *like this, not even close. They won't face one through the season.*

ESPN's *College GameDay* program was headed to Clemson for this big-stage showdown, but so was awful weather. From the beginning of the week, the forecast was grim as a stagnant front sat over the state and brought loads of rain and heavy winds to the party. On Thursday and Friday, alternate plans were discussed and fans wondered whether the game would be postponed. On Friday morning, Clemson released this statement:

Clemson Athletics officials met this morning and confirmed our ability to operate the game tomorrow, and as of 9:30 a.m., still feel confident in the resources needed. We spoke with highway patrol and campus police this morning and confirmed their manpower will be available. Facilities has confirmed power, plumbing and operations are still good to go. Playing surface is still good.

Amid that backdrop, Saturday dawned with considerable uncertainty as to how many people would show up and brave the elements. It seemed reasonable to think there could be five thousand empty seats, maybe even ten thousand. As it turned out, the fans filled the stadium and their support was unwavering and unforgettable. The student section was packed and loud two hours before kickoff. The harder the rains fell, the louder the fans became. They gave everything they had for a team that would have to do the same in the end.

The Tigers jumped all over the Irish early, fueled by the adrenaline and the crowd and the chance to make a major statement against the No. 6 team in the country. At halftime, Clemson was up 14–3, and it felt like the Tigers were on the verge of blowing Notre Dame out of the stadium. But the Irish would get the second-half kickoff, so matters were still very much in doubt.

Lakip was returning after the three-game suspension, and though he wasn't able to unseat Huegel for the place-kicking job, he made his presence felt on this kickoff. Lakip lowered his helmet and plowed into return man C.J. Sanders, knocking the ball loose. Clemson recovered, and moments later, Watson would skip into the end zone on a twenty-one-yard run that put Clemson up 21–3.

But it wasn't over. With the Tigers trying to put the game away on a deep ball into the end zone in the third quarter, Notre Dame intercepted and momentum turned. The Irish found a spark on offense and used big busts by Clemson's defense to hit for big plays. Down 24–16, Notre Dame was motoring down the field and within inches of the end zone after DeShone Kizer found receiver Chris Brown over the middle. Brown tried to twist and turn his way to the goal line after initial contact, but Kearse somehow found a way to reach out and knock the ball from Brown's grasp. Linebacker B.J. Goodson recovered at the four, and 2:09 was on the clock.

Clemson wasn't able to get a first down, and after two Notre Dame timeouts, the Irish took over at Clemson's thirty-two thanks to a ten-yard punt return by Fuller. The defense would have to dig deep again, clearly spent after a draining game and unable to rely on the immense depth boasted by the 2014 group. A sack of Kizer by Dodd pushed the Irish back to the thirty-eight, but on third-and-sixteen, Kizer found Amir Carlisle for twenty yards to the eighteen. Then with fifteen seconds left, Kizer hit C.J. Prosise for sixteen yards to the two. After a substitution infraction on Clemson moved the ball to the one, Torii Hunter got free on the right side thanks to a rub route. Kizer found him for a touchdown that made it 24–22, and the small knot of Notre Dame fans in the northwest end zone heaved with joy.

Artavis Scott skips into the end zone for an early touchdown against Notre Dame.

Clemson's exhausted faithful had given everything they had the entire game. But as the Irish and Tigers lined up for the two-point conversion, there weren't many people in the stadium who thought Clemson would have a chance in overtime. If the Irish converted, they were going to win this game and it was going to be a sickening defeat. That was the prevailing feeling.

Before the game, Swinney tried to prepare his players for such a moment. He reminded them of all the luxuries they receive as major college athletes. They get scholarships. They get cost-of-living stipends. They get good food. They get a bunch of cool gear. Top-of-the-line facilities. Some of the best training and coaching to prepare for the NFL. The royal treatment from just about everyone they encounter. But what neither Swinney nor anyone else could provide them when they were out there on that field against the Irish was guts—as in, the fortitude and the determination to dig deep and produce when everything was on the line, even when they didn't believe they had anything left.

Just when every orange-clad, waterlogged soul in the stadium was about to lose their guts, Clemson's defense was able to discover its last remaining shred of energy to stop Kizer short of the goal line on a quarterback power

Ben Boulware celebrates a big play against the Irish.

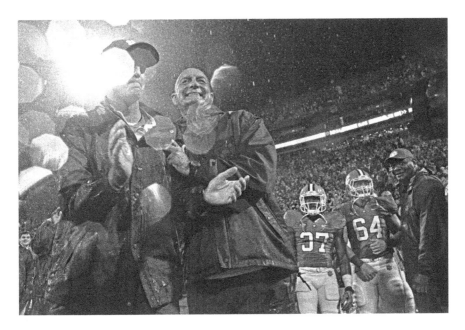

Dabo Swinney and brother Tracy in the final moments against Notre Dame.

play to the right. Dodd and Carlos Watkins pushed their guys back. Then linebacker Ben Boulware bashed in from the second level to stop Kizer short. After Zac Brooks successfully cradled the onside kick that followed, Swinney crouched on the sideline with his head in his hands—clearly emotional and thinking of his father, who had died less than two months earlier. His brother Tracy lifted him up, and the two shared a laugh before Swinney walked to midfield to shake hands with Notre Dame coach Brian Kelly.

"Notre Dame was very emotional for both of us," Tracy said, reflecting on the loss of Ervil Swinney. "It was a very important game to him, and Dad wanted to go to that game. That's all he talked about: 'Can't wait to go to Notre Dame, guys!' That's why it meant just a little bit more that game. Usually Dabo will say a short prayer after games, but I was emotional and Dabo was emotional because we knew how important this game was to Dad. I leaned down and I hugged him and said, 'Dad is here with us. You did it, man. You did it.' It was a great moment. We both have a picture of it on our desks. We both laughed and said Big Erv made that stop there at the end."

ESPN's Heather Cox corralled Swinney amid the throbbing masses who were celebrating on the field.

Man, I'm just so proud of our team. This is what it's all about. It ain't always perfect. But what I told them tonight was listen, we give you scholarships. We give you stipends. We give you meals and a place to live. We give you nice uniforms. I can't give you guts. And I can't give you heart. And tonight—hey, it was BYOG. Bring your own guts. And they brought some guts and some heart. And they never quit until the last play. And thank you to the good Lord and my dad, who was with me tonight.

Swinney wasn't finished.

"Let me just tell you: rain, sleet or snow, Tiger nation, they show!" he screamed to Cox. "And they were here tonight. Great, great job."

Meeting with reporters after the game in a corridor just outside the locker room, Clemson's players took advantage of their bragging rights. Fuller, blanketed for most of the evening by star cornerback Mackensie Alexander, finished with two catches for thirty-seven yards.

"I said a few words to Will Fuller at the two-point conversion," said defensive end Shaq Lawson, who more than held his own against elite left tackle Ronnie Stanley. "I said, 'Yeah, it's savage in Clemson, ain't it?' We just had a little talk. They weren't ready for this environment."

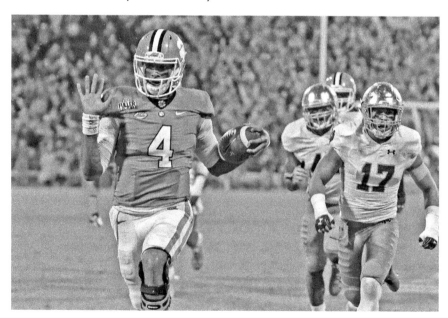

Deshaun Watson on a third-quarter touchdown run that gives the Tigers a big lead.

46

Boulware had something to say too. This two-point victory gave Clemson ten wins in its last eleven tries in games decided by seven points or less. A defense that was supposed to regress in 2015 had come up big in back-to-back games. "Everyone swore we were going to have a drop-off on defense. Everyone thought we were going to *suck*. Every one of these big games, we're never really picked to win. And it kind of pisses us off."

The source of the anger wasn't just Fuller's Tweet from earlier in the week. Another slight came when Aaron Taylor, a former Notre Dame player working for CBS, predicted that the rains would dampen the spirits of Clemson's fans and players. Swinney took particular exception to this privately with the team before the game, and then he let loose with it in his post-game press conference:

> *I don't know who Aaron Taylor is, but I guess he is an analyst or commentator. The comment was we were not going to be ready. Clemson wouldn't be ready, and our crowd was going to be lugubrious when the game was over. I don't know how to spell that. I'm hooked on phonics. I just sound it out:* Lugubrious. *But I did look it up, and lugubrious means to look sad and disappointed.*
>
> *So I want to wish Notre Dame and their lugubrious crowd safe travels back to South Bend. And we will show up in 2020. We look forward to that trip. So I appreciate the education that we got this week, the vocab lesson. The first thing our players said to me when they came to the locker room was, "Man, that Leprechaun was a little lugubrious looking."*

CHAPTER 3

FUN IN THE WINNING

Brent Venables doesn't want to get into the time or the place. He'd rather keep those details to himself.

At some point earlier in his career, Venables was in a bad place emotionally. A place where even after victories he'd find himself gnashing his teeth over the mistakes and the slivers of imperfection that obscured the main objective of it all.

"Here's what I disliked about myself: I got to a place personally where I was not enjoying the winning. And that is a very bad place to be, when you can't enjoy it."

As the wins piled up in 2015, a lot was made of how Clemson celebrated its victories with various dances in the locker room by Dabo Swinney and his players. It made for viral phenomena when Clemson's social media team captured and disseminated the clips to the world, and it certainly made for great exposure when ESPN chose to air them. One might convincingly argue that exposing this behind-the-scenes glee played a role in athletics directors seeking to fill head-coach openings with young, energetic figures who aren't afraid to let their hair down and relate to today's athlete.

But there was something more important and revealing at work in the way that the Tigers' ascending football program greeted its growing list of victories. This group was going to party like it was 1981 after every win, not just the big ones over Oklahoma or Louisville or Notre Dame. And it wasn't something that just spontaneously happened. It was a calculated part of Swinney's leadership, a ritual that provides a great

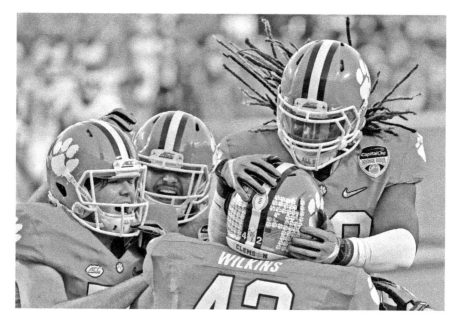

The Tigers celebrate a big play during the Orange Bowl.

safeguard against winning ever becoming the dull routine it might be at some other places.

"I just think guys get bored," Swinney said. "I think it needs to be fun. It's college football. I think part of at least what we want these guys to take away from here is I want them to have a great experience. I want them to have some fun. It's a lot of hard work, a lot of stress on these guys."

Since he took over as Clemson's coach in 2008, Swinney has said, "The fun is in the winning." The football program has changed dramatically, in many ways, over the seven years since. But one thing that has remained basically the same is how the Tigers enjoy the wins. As in, a lot.

"Coach Swinney does a really good job of making sure our guys celebrate the wins," said co–offensive coordinator Jeff Scott. "I think there's a danger when you win a lot to say, 'We expect to win, OK we won, business as usual, just kind of put your suit back on and go home.' That's really where you can find yourself in trouble, where winning is not enough and it kind of becomes boring. Coach Swinney does a masterful job, in my opinion, of having the players prepared and having that mentality to expect to win, but after we win allowing them to enjoy that and really creating the environment that he wants them to enjoy that."

Players enjoy having fun and letting loose, but coaches at this level don't find it nearly as easy. They have reached this point because they are driven to the point of obsession. And the line between devotion and obsession is one that's not easily recognized. When your team wins, you immediately start thinking about the next game. When the season is over, you immediately start thinking about your next recruiting class. When recruiting is over, you immediately start thinking about spring practice. On and on the cycle goes. When you lose too much, you're looking for another job. When you're winning, you're trying to do everything possible to continue winning. Before long, you lose important perspective and you forget to enjoy the success that you've worked so hard to accomplish.

In a fall interview with Dan Patrick, Ohio State coach Urban Meyer recalled the immediate aftermath of his Florida team's victory over Oklahoma in the 2008 BCS title game. As he walked off the field in South Florida, he began to worry about his underclassmen who might be going pro. He went straight to a room, locked the door behind him and spent fifteen minutes e-mailing recruits.

"They're celebrating a win, and I'm in there e-mailing recruits," Meyer said. "I mean, to the point that people were knocking on the door and

Co–offensive coordinator Jeff Scott during the Orange Bowl.

Brent Venables and Adrian Baker.

saying, 'Come on, man, enjoy it.' I think obsessive behavior, where you don't actually enjoy the moment, is not good. And I witnessed that."

After leaving Kansas State to join Bob Stoops at Oklahoma in 1999, Venables was part of a program that quickly rose from mediocre to powerhouse. When the Sooners won seven games that first year, it was new and exciting. And it was an intoxicating thrill the next year when they went 13-0 and brought a BCS title to Norman. The Sooners won a lot of games over the next eleven seasons, but they couldn't win another BCS title.

"I've been in a lot of happy locker rooms, here and a lot of other places," Venables said. "But I've also been a part of winning a lot and not enjoying it. I was in that other place, where I just can't be happy. When you have so much success and then you're not quite there, sometimes you just get into a bad place where nothing is good enough until you have it all. And then you're really probably not satisfied there, either."

In January 2012, Venables made the surprising move to leave Stoops and the good job he had at Oklahoma. He wanted to push himself out of his comfort zone, and something about Swinney and Clemson appealed to his desire to continue growing and learning as a coach and person. Working for Swinney has been a revelation in a lot of ways for Venables, and one of them is how Swinney has brought perspective and balance to the program as a whole. He said:

It's helped me in a lot of ways, as much personally as it has professionally. This has been an incredible environment for my family and myself. To be under a new leader, it's been incredibly beneficial to learn a ton from Coach Swinney. I just love the environment that our team is in and I'm able to come to work in every day. Again, it's about the players and their well-being and keeping the main thing the main thing and continuing to pursue what's right by these kids. And the winning and the success is a byproduct of having a healthy environment and a healthy locker room. When you believe in it and that's your passion, starting with Coach Swinney and the people he's surrounded himself with, that's been a lot of fun and it's really helped me grow and learn professionally. Coach Swinney is a great example for all of us, players and coaches alike. I've benefited in a lot of ways.

A big part of Swinney's message isn't just thoroughly enjoying the wins but being able to avoid total devastation after the losses too.

"He's the first one to tell us that if we lose we're not going to get skinned alive," Venables said. "None of us are going to like it, but we're not dying. It could be a lot worse."

Said Swinney: "I would hate to be at a place where you walk off the field and you win the game and everybody just comes in and says, 'All right boys, atta boy,' and you don't really celebrate the moment. Because at the end of the day, the moment is what it's all about."

The fun is in the winning, and the Tigers have had a lot of fun.

"You've got a great culture that promotes success," Venables said. "It promotes the little steps in life, one on one, and recognizes it along the way and enjoys the journey…We enjoy the process, the journey, life, all of it. It's human nature as coaches: you remember the bad plays and you want more and you want to play better. As a leader, Coach Swinney is constantly on us about 'We are not going to be that way.' And it's not like he says it every once in a while. Fortunately, we've won a lot, so he continues to promote it."

BEACH SLAP

The two home games that followed the conquest of Notre Dame were against Georgia Tech and Boston College, and the Tigers showed no letdown when some outsiders were warning of one. The most eventful part of those two games came off the field, after the 43–24 win over the Yellow Jackets, when Dabo Swinney went ballistic.

Before Swinney stepped to the microphone wearing a dapper gray suit with a purple and orange tie, the story was about Clemson's complete dominance of Paul Johnson's flexbone offense. Johnson had caused plenty of heartache for Swinney and the Tigers since his first year in 2008, when he handed Clemson a 21–17 defeat in Swinney's first game as interim coach. In 2009, Georgia Tech beat Clemson during the regular season and then handed the Tigers an excruciating 39–34 defeat in the ACC title game. In 2011, the Yellow Jackets derailed Clemson's 8-0 joy ride in a 31–17 thumping in Atlanta. And then in 2014, a 28–6 loss to Georgia Tech was the Tigers' lone defeat in their final ten games. So there were plenty of demons there that weren't all chased away by wins over Johnson and the Yellow Jackets in 2010, 2012 and 2013.

In this meeting, Johnson's 100th game at Georgia Tech, Brent Venables's defense limited the Yellow Jackets to their lowest rushing total under Johnson with 71 yards on forty-two carries. In its previous eight games against Johnson's teams, Clemson had allowed 288 rushing yards a game. For most of the second half, and for about an hour after the game, this was the story. A close second was an offense that turned pyrotechnic after sputters against Notre Dame and Louisville.

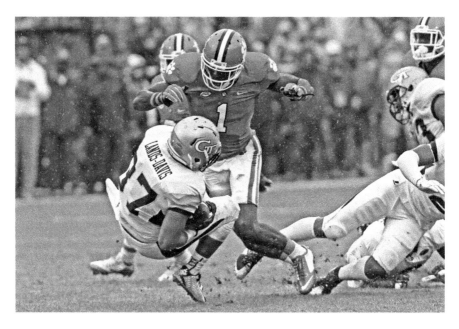

Jayron Kearse with a big hit against Georgia Tech.

"When you run the triple option and you can't run the football, it's a long day for you," Swinney said. "That's the story of the day. It's that simple."

Then a reporter from ESPN asked a question that included the term "Clemsoning," and the story changed. The reporter was David Hale, who lives in Charlotte and covers the ACC. Hale had a long history of defending Clemson in the face of lazy assumptions made by other commentators who wondered whether Clemson would collapse in a big moment. Once upon a time, the Tigers had a habit of losing to inferior teams and falling apart when the stakes were highest. But their last loss to an unranked team came in 2011, and this was their thirty-third consecutive victory against foes out of the Top 25. Since that loss to unranked NC State in November 2011, fifty ranked teams had lost to unranked teams. The Tigers also had a growing list of big-name victories, including LSU, Ohio State, Georgia, Oklahoma and Notre Dame. They had done more than enough to flush the derogatory "Clemsoning" term that was hatched as a result of those failures from years ago. And that's what Hale was getting at when he asked the question. He just made the mistake of saying the word.

Here was the question:

Dabo, you talked about people saying how possibly are you going to get ready for this game, and I know as unfair as that term has been and the way it's been applied to Clemson, the whole "Clemsoning" thing and losing games you're not supposed to, how does this team kind of approach that differently in your mind? Is it a matter of, like you said, that you're focused on one game at a time? Or is it a matter of they don't even think about it anymore?

In recent weeks, Swinney had mentioned the lack of respect his team was getting from the national media. Just that morning, ESPN's *GameDay* program had extensively debated whether it was time to bury the Clemsoning term. One could sense his frustration building into a blowup, and it just so happened that Hale was the recipient.

Well, I think it's ridiculous that you're even asking me that question, that you even say the word. I mean, I'm serious. I'm sick of it. I don't even know why we even bring up the dad-gum word. How about some of these other teams out there that lose to unranked opponents all the time? That's our thirty-third win versus an unranked opponent. We ain't lost to anybody unranked since 2011, but I have to come to a press conference in 2015 and get asked that. And that's all media bull crap. I can tell you how they feel about it. They don't like it. It's a lack of respect. It's not doing your homework and paying attention to what reality is. Should not be asked that question. Period. That's how we feel about it. This football team right here has earned the respect. Ain't nobody given us anything. Not one ounce of anything. They've earned everything they got. And when I have to turn on the TV and people bring up that word, and they try to casually throw the word out there like you do, but it's still a word. It shouldn't even be in the conversation. That's how they feel about it. That's how I feel about it.

Hale tried to apologize, but Swinney was off and running.

Same thing today. Rhetoric on TV today. Same old bull crap. People need to get some more adjectives. This football team has shown up. What else they got to do? We've beaten Ohio State, Notre Dame, LSU, Oklahoma, Georgia, Auburn. We've beaten thirty-three unranked opponents in a row. We're 7-3 versus Top 10 teams. People need to quit talking about that. It's like people are trying to push their own agenda out there. And I can't

believe I've got to come in here with a 5-0 football team that just had a
great win and have to be talked about "Clemsoning." It shouldn't even be
in the conversation.

Hale tried to rephrase his question, saying he was trying to underscore
the angle that Clemson performed quite well, even after a huge win. But
Swinney was still going.

If we lose this week, it ain't because of Clemsoning. It's because we just got
beat. We're human. We're just human. Good God almighty, man. Look all
over the country, you've got all kind of teams out there getting beat. I mean
we're a football team that has earned everything they've got. And to answer
your question: they don't like that. It's a lack of respect for what these guys
have done. This program doesn't take a back seat to anybody. We're not
better than anybody. We could lose. Boston College, that's the biggest game
of the year. And they're dang capable of beating us. Had a great chance
to beat us last year. We were fortunate as heck to win that game. But we
won it. And if they beat us, it ain't because we had some bad whatever.
It's because they just beat us. That's football. It's like everybody is sitting
around waiting on us to lose a game so they can say, "Oh well, there you go
again." Well no, that's bull crap. Next question.

Hale approached Swinney as Swinney left the press conference, and they
had a cordial conversation. Swinney later texted Hale to smooth things over,
telling him he should've just said "no comment."

The rant created a sensation that lasted well into the following week and
into a 34–17 win over Boston College. It overshadowed the progress of
an offense that was starting to shift into a higher gear after getting bogged
down the previous two games. Against the Cardinals, the Tigers totaled
401 yards but couldn't cash in on several scoring opportunities. Against the
Irish, Clemson shifted into neutral after a hot first quarter and finished with
296 yards. Fans were wondering about Deshaun Watson's ability to throw
the deep ball accurately, and they were questioning whether Swinney's
decision to name Tony Elliott and Jeff Scott co-coordinators was the right
move. Despite scoring a total of 44 points in those two games, Swinney
and the coaches weren't the least bit worried. They knew this offense was
still adjusting to the loss of Mike Williams, still trying to find a reliable
third-down threat. They knew Louisville and Notre Dame had really good
defenses. They knew a young offensive line would continue to develop and

grow. They believed strongly that Watson and the offense would get more comfortable and start putting up big numbers, and that's exactly what happened against the Yellow Jackets and Eagles. The Tigers amassed 537 yards against the former and 532 against the latter, creating confidence that the offense could do pretty much whatever it wanted heading into a trip to Miami to face the Hurricanes.

The visit to South Florida gave long-timers an opportunity to reflect on how much had changed since the last time the Tigers played the Hurricanes on their home turf. That would have been 2009, Swinney's first full season as the Tigers' coach, when the Tigers pulled off a dramatic 40–37 overtime triumph. Back then, such a win on the road over a Top 10 team was new and almost unexpected. Jacoby Ford, a senior on that team, caught the game-winning touchdown pass from Kyle Parker in overtime, and it felt like one of the biggest wins in school history at the time. The victory over Notre Dame improved Swinney's record to 7-4 against Top 10 teams.

Said Ford:

The program is vastly different from the time I was here, just as far as pretty much everything—facilities, recruiting, videos, everything they do here now is just high standard. That's kind of what we were hoping to do when we were here was kind of get this program going and put it on a pedestal. Now, it's definitely one of the best programs out there if not the best, as far as recruiting and playing and the whole environment and just everybody coming together in this small town of Clemson on Saturdays and rooting the Tigers on. Just the way that they've transformed the whole atmosphere here, it's amazing.

Miami came into this game with a 4-2 record but in desperate need of a big win under embattled coach Al Golden. Two weeks earlier, the Hurricanes had gone to Florida State and pushed the Seminoles to the limit before falling 29–24. Miami had beaten Virginia Tech 30–20 a week earlier, but that wasn't anything special because the Hokies were mediocre. And it wasn't enough to stop the planes that flew above the Hurricanes' stadium, dragging banners that called for Golden's ouster. This was viewed as Golden's chance to put up or shut up, and his players couldn't shut up during pre-game warmups. The Hurricanes were mouthy as the two teams arrived to the field before putting on the pads, and multiple scuffles broke out. It was the most fight Miami showed all day.

The Tigers gather on the field at Miami.

Swinney has built an impressive record of knocking off some of the more acclaimed names in college football. In this ruthless 58–0 plundering, he added something new to his résumé: putting mediocre coaches out of work. Golden was fired the next day after absorbing the worst loss in program history, surpassing a 56-point loss to Texas A&M in 1944.

"Awesome, awesome win," said Swinney, whose team improved to 7-0. "Complete performance in all three phases."

Clemson's margin of victory tied its largest in an ACC game, matching the 82–24 smashing of Wake Forest in the 1981 national title season. Said Florida native Jayron Kearse: "We had to come out and show we are for real."

One of the few things Swinney could find fault with on the entire day was how his team celebrated toward the end of a first-half barrage that left the Tigers up 42–0. Miami's players were jawing and strutting even when they were getting humiliated. Clemson's players responded with a little of their own. Swinney didn't like it, so he gathered his team on the field before they went into the locker room and told them he wanted them to handle themselves with class. He told his players that women and children were watching, and the final statistics should have come with some sort of parental-guidance warning:

Total yardage: 567–146
Rushing yardage: 416–53
First downs: 33–6

Some people who didn't watch the game closely might have said quarterback Brad Kaaya's absence, sealed on an early hit by Shaq Lawson, played a role in this one. But it was 28–0 at that point, the Tigers well on their way to administering a beatdown of historic proportions. A week earlier against Boston College, Clemson had 112 rushing yards. At Miami, quarterbacks Deshaun Watson and Kelly Bryant combined for 157 yards on the ground by themselves. The Tigers scored touchdowns on five of their first six possessions, and four of the drives were of 80-plus yards. In its previous two games, the offense had totaled eight touchdown drives of 75 yards or more.

Golden, whose record dropped to 32-23 in his fifth season at Miami, said his team's performance was "inexcusable and intolerable." "We helped a really good football team today."

In the other locker room, Swinney was trying to find some mistakes that coaches call "teachable moments." He probably didn't find many.

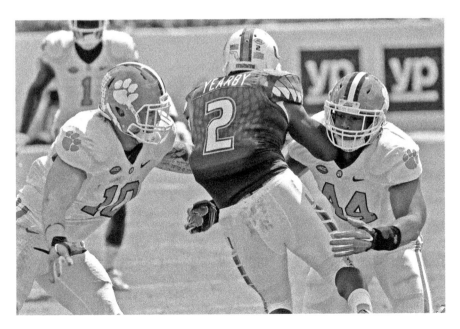

Ben Boulware and BJ Goodson converge on Miami running back Joseph Yearby.

"Today was just a near flawless performance," Swinney said. "They were just ready to go. Our plan to win that we talk about all the time, we won every facet of it. And that was why it was a dominant performance."

After a closer-than-expected win over Boston College brought questions about needing to accumulate style points for the College Football Playoff selection committee, the Tigers left Miami looking quite stylish and attractive. A little more than a week before the committee's first ranking of the season, this was when Clemson went from looking really good to scary good. And it seemed plenty realistic to think the Tigers could be back at the same stadium for the semifinals of the College Football Playoff on December 31.

TWIST OF FATE

Clemson fans can thank Woody Hayes for helping pave Mitch Hyatt's path to Clemson. That doesn't make much sense at first, because Hyatt was born in 1997. That's almost ten years after Hayes died. And it's almost two decades after Hayes ended his coaching career with a punch of a backup Clemson nose guard named Charlie Bauman.

It starts to become much clearer, and more remarkable, when you learn exactly how Hyatt's uncle Dan Benish ended up at Clemson.

"If all that stuff doesn't happen," Benish said, referring to the fallout from Hayes's punch in the 1978 Gator Bowl, "I probably would have never ended up down south. Pretty much my whole family wouldn't have moved down south."

So it's logical, then, to conclude that Hyatt would have never ended up wearing orange and protecting Deshaun Watson's blind side as a precocious freshman left tackle in 2015.

"Exactly," Benish said. "You never know, but it's almost 100 percent he wouldn't be there."

Benish, who played at Clemson from 1979 to 1982 and was a starting defensive tackle on the 1981 national title team, has often said that he was headed to Ohio State until Hayes's punch turned him toward Clemson. That makes sense, because Benish is from the outskirts of Youngstown in northeast Ohio. When you hear that surface recollection, the tendency is to make a surface conclusion that Benish merely reconsidered his college destination after Hayes's firing. But then you call Benish and ask him the how and the why of this story, and the story becomes extraordinary.

Leading to the Gator Bowl that year, Clemson was barely on Benish's radar. A Tigers assistant named Mike Bugar was from Ohio and had reached out to Benish, but at that time the Tigers football program was a total obscurity to kids from the Midwest.

"There weren't many games on television back then," Benish said. "There were just three channels. Notre Dame was always on TV, Ohio State and Penn State every now and then. I had no idea where Clemson was."

A couple days after the Gator Bowl, Benish was scheduled to take his official visit to Columbus. The papers were full of news about the punch and the firing that closely followed, greatly overshadowing a mammoth victory in Danny Ford's first game as Clemson's head coach after Charley Pell's abrupt departure for Florida. Nevertheless, Benish rode to the airport with his mother to catch the flight. She dropped him off. He went to the counter to get the ticket that Ohio State had left for him. Only, there was no ticket. From the airport, Benish called Ohio State to ask what was going on. Ohio State informed him that Hayes, on his way out, happened to take every last shred of recruiting records and information.

"There were no computers back then, so everything was done on paper," Benish said. "Woody took everything when he left. So there was no ticket for me, no record of my flight, and I'm stuck at the airport."

Benish happened to run into a fellow high school player who was headed to Clemson for a visit. A few phone calls were made. Ford signed off on a ticket for Benish to fly to Clemson. Thirty minutes later, he was on a flight to the Palmetto State when his family thought he was on a quick trip to Columbus. The place he left was cold and snowy. The place he was going was sunny and seventy-five degrees in January. His first stop when he arrived in Clemson was a sporting goods store so he could ditch the heavy jacket and cold-weather gear for a T-shirt and more leisurely clothing. The simple act of strolling down College Avenue was a revelation.

"In Ohio, you walk around with your head down and no one says anything to you," Benish said. "In Clemson, you walk around and strangers are coming up and talking to you."

Benish, now fifty-four, recalls the unmistakable feeling of something special brewing with the football program. After eight losing seasons over a nine-year stretch from 1968 to 1976, the Tigers quickly ascended to prominence with an 8-win season in 1977 and an 11-1 mark in 1978. Pell delivered a debilitating hit to the collective psyche by leaving for Gainesville after just two seasons, but there was still a sense of momentum and magic after the Gator Bowl and a No. 6 final ranking.

Above: Dabo Swinney shows off his coat during Tiger Walk before the Appalachian State game.

Left: Dabo Swinney, Brent Venables and Dan Brooks.

The locker room after Notre Dame.

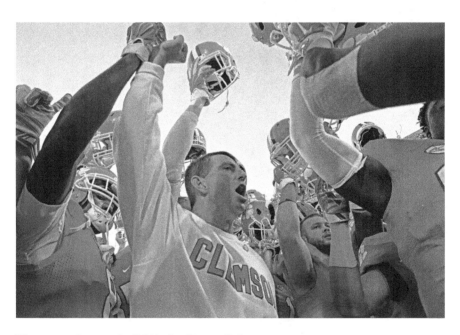

The team gathers on the field before Boston College.

The scene outside Death Valley after a touchdown.

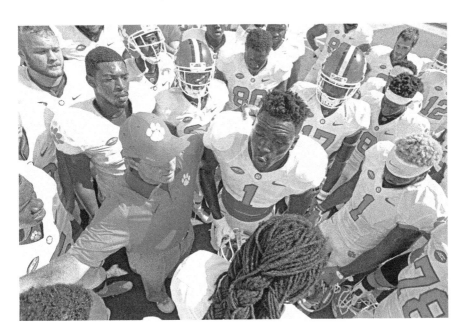

Jayron Kearse with some choice words before the Miami game.

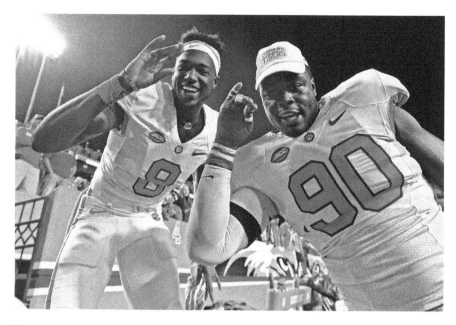

Deon Cain and Shaq Lawson in the closing moments at NC State.

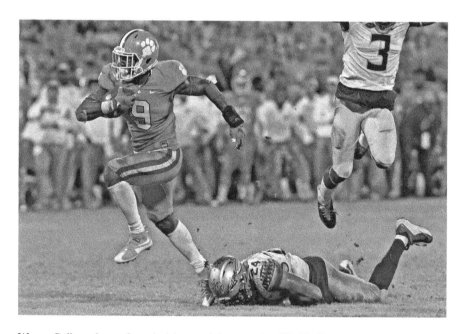

Wayne Gallman bursts for a decisive touchdown against Florida State.

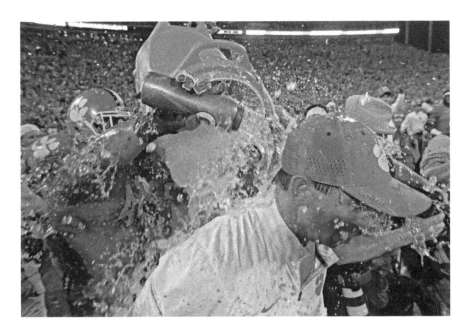

The Tigers celebrate their first win over the Seminoles since 2011.

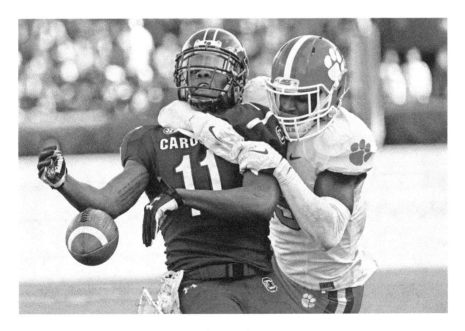

T.J. Green takes down South Carolina's Pharoh Cooper.

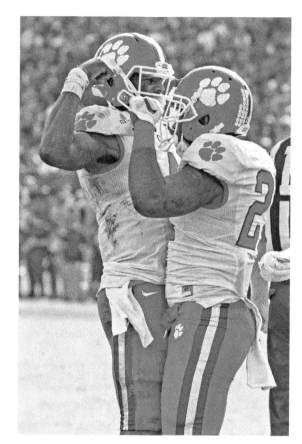

Right: Deshaun Watson
and C.J. Fuller flex their
muscles after a touchdown in
Columbia.

Below: Jeff Scott and Dabo
Swinney during the ACC
championship.

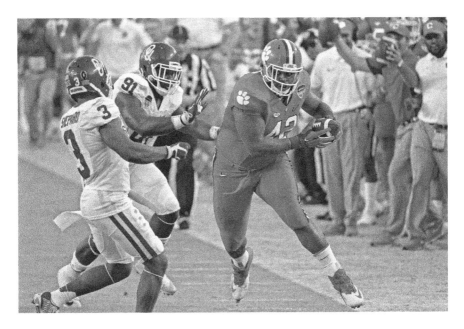

Christian Wilkins barrels for yardage on a fake punt against Oklahoma.

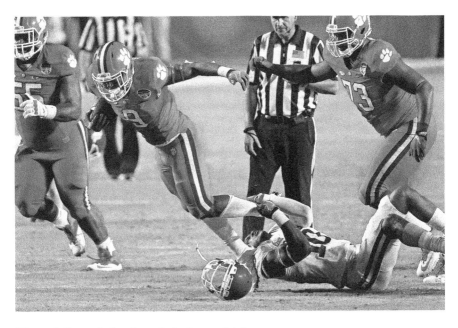

Wayne Gallman slashes through the Sooners' defense.

The team celebrates the win over Oklahoma.

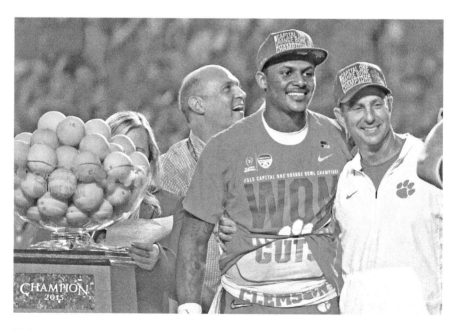

University president Jim Clements joins the team on the stage at the Orange Bowl.

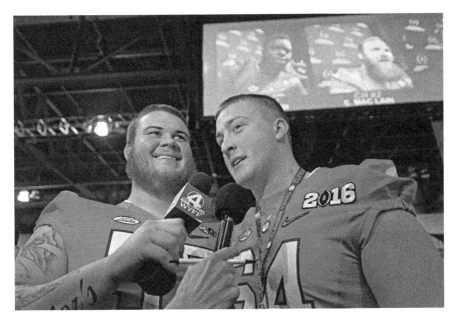

The Tigers cut up during national championship media day.

Deshaun Watson before the national title game.

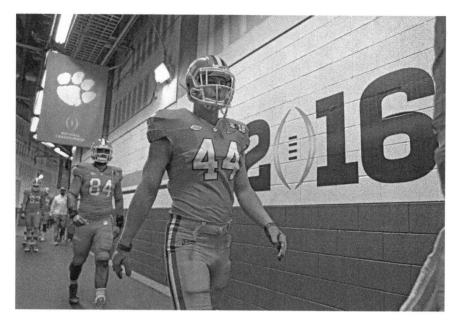

Garrett Williams and the Tigers walk from the locker room before the national championship.

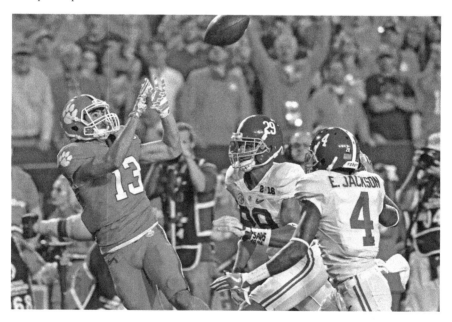

Hunter Renfrow with a touchdown catch against Alabama.

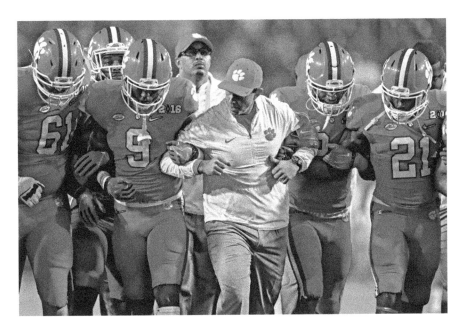

Dabo Swinney and the Tigers before the national championship.

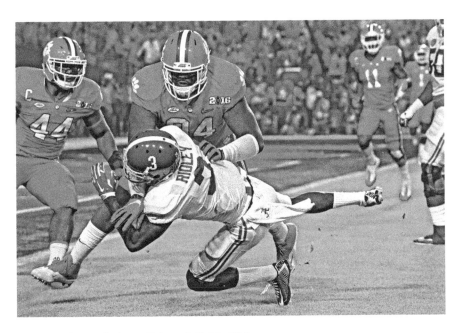

Carlos Watkins pulls down Alabama's Calvin Ridley.

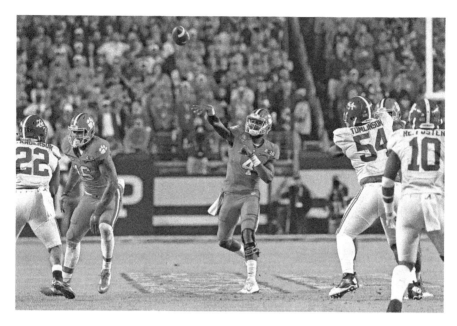

Deshaun Watson rifles a deep ball.

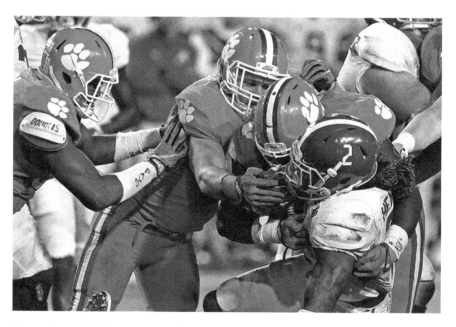

The defense stuffs Heisman winner Derrick Henry.

Right: Derrick Henry brought down for a loss.

Below: Dabo Swinney with his kickoff team.

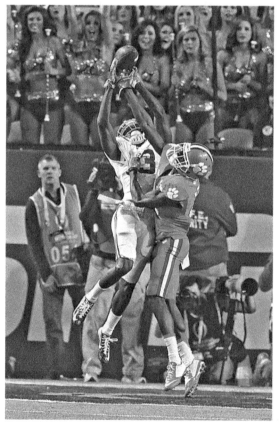

Above: Deshaun Watson drops
back.

Left: An Alabama deep ball is
broken up.

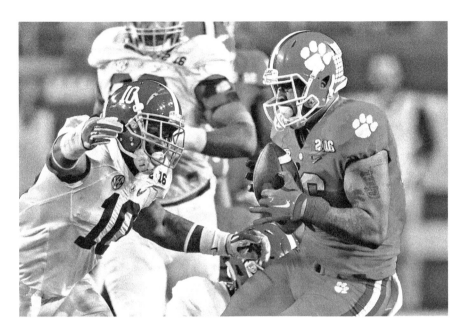

Jordan Leggett with a catch over the middle.

T.J. Green and Jayron Kearse, inconsolable after the loss to Alabama.

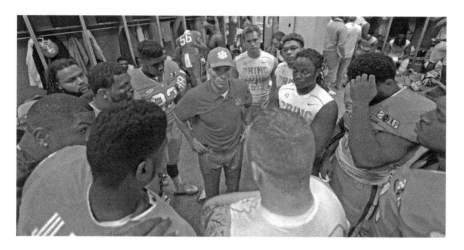

Brent Venables addresses his linebackers in the locker room.

Former Tiger great Tajh Boyd consoles Deshaun Watson.

The feeling and the vibe was very similar decades later when Benish brought his nephew on a recruiting visit to Clemson. After the breakthrough season in 2011, the Tigers ascended higher by winning thirty-two games the next three seasons and claiming big victories over Auburn, LSU, Georgia, Ohio State and Oklahoma. The roller coaster days of Tommy Bowden seemed far in the rearview mirror. An elite offensive line was considered the missing piece that could take the Tigers to the highest level, and Hyatt was the type of lineman they needed. He finished up high school in December 2014 and enrolled at Clemson the next month.

"There was a vibe you felt that something special was going on when I visited in 1979," Benish said. "It was the same thing that you felt when Mitch was going through his recruitment and we visited campus. I told him that."

Benish spent six years in the NFL, first with the Falcons and then with the Redskins. During his time in Atlanta, various family members moved to Georgia from Ohio—his mother, two brothers and a sister who's now otherwise known as Mitch Hyatt's mother.

"We've all been in the South ever since," Benish said.

Benish began bringing his now-famous nephew to Clemson games around age seven. He remembers Hyatt being so skinny as a kid that he had to use tape to keep his pants up when he was playing youth-league football. Between the seventh and eighth grades, Hyatt grew eight inches. By the start of his sophomore year, he was starting in the Georgia Dome for North Gwinnett High School at the Corky Kell Classic and holding his own against older, more decorated players.

Enrolling early allowed Hyatt to get a head start on playing as a freshman, something that's extraordinarily difficult for offensive linemen at the college level. The history at Clemson didn't exactly portend a stellar season for Hyatt. Since 1986, just five freshman offensive linemen at the school played at least 97 snaps in a season: Barry Richardson in 2004 (471 snaps), Akil Smith in 1998 (240), Antoine McClain in 2008 (149), Brandon Pilgrim in 2003 (145) and Marion Dukes in 2003 (97).

The coaches loved what they saw from Hyatt during spring practice, though they knew he'd have to get stronger and add more muscle to his 270-pound frame by the start of the season. Hyatt was the backup left tackle behind senior Isaiah Battle, and at the time it was assumed there was a vast gap between the two. Quietly, the coaches believed Hyatt was capable of beating out Battle if his upward trajectory continued.

Hyatt spent plenty of time in the spring battling Shaq Lawson, a physical and fast end who was replacing star rush end Vic Beasley. Lawson won most

of the battles, but Hyatt kept getting right back up and asking for more. He didn't back down from a challenge, and he even engaged in scuffles here and there. It was abundantly clear that Hyatt was not your typical freshman offensive tackle.

"I really thought he would play a lot and play early," Dabo Swinney said. "Watching him in the spring after getting his face beat in by Shaq Lawson, he just kept coming. I knew this kid would really help us. He's just strong and athletic, great feet, great technician and knows how to use his body. He studies tips, too. He studies the opponent relentlessly. He's going to get in that weight room and will be a 305-, 310-pound guy by the time it's all said and done."

The summer brought news that Battle was gone, leaving for the NFL's supplemental draft after a brush with the law. This created what seemed an urgent situation with a first-year freshman starting at left tackle. But inside the football offices, there was very little alarm. Lawson had dominated Hyatt over the first week or two of August camp, but then Hyatt battled back and played Lawson on even terms for the rest of practice. The staff felt comfortable, reasoning that Lawson was probably the best defensive end Hyatt would face all year.

Hyatt ended up starting every game, the first freshman lineman to do that at Clemson since 1944, and improved as the season progressed. At midseason, he became the first freshman in ten years to be named the ACC's offensive lineman of the week. By the end of the year, he had amassed the most plays by a rookie offensive lineman in school history and earned third-team All-ACC honors. He was named freshman All-America by *USA Today* and the *Sporting News*. Swinney said those feats are "near impossible" for a lineman who's a year removed from high school.

"Nobody ever asks me about him," Swinney said in December as the Tigers prepared for Oklahoma. "This is a true freshman left tackle, and we've had thirteen game plans and not one time this year have we helped him, meaning chipped protection or sliding protection over to him. He has played left tackle like he is a senior. He's been amazing."

Hyatt's rapid progress made play-calling easier for first-year co–offensive coordinator Tony Elliott, whose offense began to take off in the fifth game. Elliott said there are numerous similarities Hyatt shares with Watson, who had his own special freshman season in 2014 after joining the Tigers as an early enrollee. Both players are excellent students, and both seem wise beyond their years on and off the field.

"What drives Deshaun is what drives Mitch Hyatt," Elliott said. "They love the game; they respect the game. They understand that regardless of what

their talent is, talent is never enough. You've got to put in that work. You've got to be driven, you've got to be focused and you've got to prepare every week. I think that's more important than the status and accolades that they have."

Equally amazing is the twist of fate that indirectly led Hyatt to Clemson. Benish said he never heard from the Buckeyes' coaches after that day at the airport in 1979. Where would Hyatt be right now had Hayes not taken all those recruiting records, had his uncle landed at Ohio State?

Woody threw the punch and made off with a bunch of files. Clemson made off with two pretty good football players.

"I had no idea that a coach leaving like that would affect me and my family that much, but it really did," Benish said. "At that point they hadn't named a head coach, and I was like, 'Ohio State doesn't want me, so I don't want to be there.' No one at Ohio State reached out to me again. It was amazing."

CHAPTER 6
PERFECT HARMONY

Typically, not much interesting happens at a groundbreaking ceremony. Donors are thanked. Photos are snapped. Important people take off their hard hats and discard the shovels, and everyone moves on.

The day before Clemson played host to Florida State with a chance to claim the ACC's Atlantic Division, they staged an event to turn ceremonial dirt on a $55 million football operations facility. And it was anything but a routine endeavor.

A few days earlier, the 8-0 Tigers were unveiled as the No. 1 team in the country in the first College Football Playoff poll of 2015. Now, Swinney stepped to the microphone and was trying to thank the donors who had bought into his vision of not just keeping up with what everyone else in college football is doing but staying ahead of them. There was a time when Clemson did just enough to remain competitive in the ever-evolving arms race of facilities improvements and coaches' compensation. But those days are over, thanks to Swinney selling his administration on a commitment to dictating the cutting edge instead of reacting to it. This event was being held at the team's $10 million indoor practice facility, which was completed in 2012 after years of lobbying from Swinney. Now he was here to celebrate the start of something much bigger: a sprawling, all-encompassing complex that would house all of the Tigers' football operations for a long time. Kind of like a forever home for a major college football program.

Swinney, seldom at a loss for words, choked back tears.

"I've just been full of emotion the whole year," he said, alluding to his father's passing in August. An extended pause followed as he tried to compose himself. Someone in the audience shouted, "We love you, Dabo!" Applause followed, and Swinney began to lose it again before turning his back to the crowd. He used his suit jacket to wipe away the tears.

"It takes a lot of people," Swinney said before another pause. "It's rare in college that you have everything kind of working in the same direction. I've seen where the president doesn't like the AD, the AD don't like the president. The head coach thinks he calls all the shots, he doesn't understand the chain of command. The board of trustees don't like whatever. I've seen that. It's an ugly thing. Everybody worries about who gets the credit. But I've never been a part of a better situation than the one we have right now at Clemson as far as the synergy, the unity of spirit. Clemson has a determined spirit. And that's why we're having success."

For two decades, Clemson couldn't figure out what it wanted to be on the football field. Danny Ford ushered in unprecedented success in the 1980s, bringing the 1981 national title to the foothills of the Palmetto State and establishing the Tigers as a perennial power. But he also brought NCAA scrutiny and strife with the administration that ultimately resulted in his messy departure in 1990. That produced years of conflicting interests and conflicting ideas and conflicting definitions of what Clemson football should aspire to be. Everyone wanted the Tigers to win, but there was paranoia about the perception of winning at all costs. To replace Ford, they brought in straight-laced Ken Hatfield before deciding he wasn't a good fit. Then they brought in Tommy West, who talked like Ford but didn't win like him. Then they brought in the hot young name (Tommy Bowden) but took years to supply him with modern facilities.

In four full seasons as a receivers coach at Clemson, Swinney was paying attention, and he noticed some of the cultural weaknesses that were holding Clemson back. When Terry Don Phillips made the surprising decision to name him interim coach in October 2008 after Bowden walked, Swinney's long-term vision consisted of unifying the entire Clemson family and making the football product stronger as a result. The "All In" mantra he voiced on the first day of the job wasn't just something to rally his players that week; it was a broader message underscoring what could be achieved over the long term with everyone devoted to the same goal.

When you examine the administrative chain of command above Swinney, you notice that none of the important figures was in his current position when Swinney took over in 2008. Dan Radakovich replaced Phillips as

athletics director after Phillips retired in 2012. Jim Clements came from West Virginia to replace Jim Barker as president. Bill Hendrix was the chairman of the board of trustees when Swinney was promoted, followed by David Wilkins and now first-year chair Smyth McKissick. This is the sort of turnover that makes coaches nervous because typically changes above mean new priorities and new egos and conflicts with superiors. Down the road in Athens, Mark Richt clashed with his administration after changes at the AD and presidential levels before his firing in November 2015. At Oklahoma, Bob Stoops has endured significant criticism from outside in recent years but remained there largely because the two men who hired him—athletics director Joe Castiglione and President David Boren—were still in place and still his biggest allies.

At Clemson, it's quite common for Clements to take an active role in recruiting when football prospects visit campus. At basketball games, the president often sits with Swinney and other members of the football staff. Trustees are frequent visitors to the locker room after games, and once a year, the entire board travels with the team to a road game. Wilkins, the former U.S. ambassador to Canada, played a major role in improving the relationship between the administration and athletics department.

"I think we've got the right person in charge," said Wilkins, who served as chairman from 2009 to 2015. "He's created the right culture. I think you've got to start at the top, with the ability of the AD at the time to see something in this wide receivers coach, to tell him that he could lead a major university and lead the team. But then once he got the opportunity, Dabo Swinney has changed the culture over there to winning. He's surrounded himself with good people. The administration has supported him, and the board has supported him, too, in salaries and capital improvements."

Swinney's second full season ended in nightmarish fashion in 2010 when the Tigers were blown out at home by South Carolina and lost to South Florida in the Meineke Car Care Bowl. Clemson finished with a losing record (6-7) for the first time in twelve years, and Swinney was responsible for the Tigers' first back-to-back losses to the Gamecocks since 1970. On the outside it was not pretty, as fans railed on Phillips for hiring an inexperienced coach and called for the AD's firing. On the inside, the administration doubled down on its commitment to Swinney and the football program by signing off on various upgrades to facilities and salaries. Less than a year later, after first-year offensive coordinator Chad Morris helped orchestrate a dramatic revival of the Tigers' offense, the board of trustees committed to making Morris the highest-paid coordinator in college football with a $1.3

million salary. The Tigers won ten games and claimed the ACC title that year with a smashing of perennial conference power Virginia Tech, further solidifying Swinney's message and vision. Two years later, the administration signed off on Swinney hiring Thad Turnipseed from Alabama and charging him with building a recruiting communications department that interacts with prospects on social media. Turnipseed also played a major role in the conceiving and designing of the $55 million football operations facility.

The fall of 2015 brought extraordinary turnover in the coaching ranks, highlighted by the abrupt departure of South Carolina's Steve Spurrier after six games. As athletics directors did their homework and tried to find the ideal candidate to lead their programs, a common prototype emerged of a young, energetic coach who had the ability to relate to recruits and players while galvanizing a fan base. Not long ago, the ideal head coaching candidate was the stern, authoritarian presence best exemplified by Alabama's Nick Saban and his much-imitated "process." Now, schools were looking for marketability. And it was hard to argue against the notion that Swinney had become the model for what presidents and athletics directors were seeking in their coaches. After Spurrier and Gamecocks fans spent years ridiculing Swinney for his exuberant behavior, South Carolina went the same route Clemson did with Swinney by promoting an energetic assistant named Shawn Elliott to audition for the job after Spurrier left. On his way out, the seventy-year-old Spurrier acknowledged it's a young man's game now and said it was time for the Gamecocks to find someone who could compete on the recruiting trail with Swinney and other coaches who consider talent procurement a way of life.

In November, Swinney reflected on the fruition of the vision he had when he took over the Tigers' program as a thirty-nine-year-old "walk-on coach." He recalled fighting with the administration early in his tenure, arguing that they needed to invest in expanding the football support staff and modernizing the way the program communicated with recruits. He recalled moving into a brand-new football facility before his first full season in 2009 but still retaining the thirst to continue looking ahead and then later building toward the facility he turned dirt on the day before the Florida State game. Swinney received his master's degree in business administration at Alabama in 1995, and the following insights paint the picture of a successful football CEO:

In the business world, you look at the old bell curve of a business:
You've got the birth. You've got the growth. You've got plateau. You've

got decline. And you've got death. Those great businesses out there, those great programs, they don't plateau. So how do you do that? You have to constantly reinvent, reinvest, reset, learn, grow. You change. You have to do that. You don't just change to change, but you have to always challenge yourself each and every year and make sure, "OK, this may be how we've done it, but is it still the right way?" At least ask those type of questions. I think every successful business, every consistent program, that's a mentality. You can't be satisfied. Because just as soon as you think you've arrived and you're satisfied, then you plateau and then the next thing you know you're on that decline. Now you're not paying attention to the little things. You don't have the sense of urgency because you're fat and happy. And then it's death. The business is closed, or whatever.

Swinney is one of the few coaches out there who does not maintain a Twitter account. He's a bit old-fashioned in that way. But his personal methods of communication stand in direct contrast to his views on how his staff and his program should communicate with recruits. Dating to the days when he and recruiting coordinator Jeff Scott went full-throttle on outfitting the entire staff with smart phones when smart phones were a new thing, Swinney has been committed to doing cutting-edge things. That's abundantly evident in the sprawling recruiting communications staff overseen by Turnipseed. It's also evident in the constant orange-splashed social-media saturation by D.J. Gordon, Jonathan Gantt, Jeff Kallin and others on the athletics department's communications staff. Swinney doesn't spend his time on social media, but when the platform began to emerge as an avenue of recruiting communication, he was finely attuned to the possibilities and the importance of investing in it.

"We want to be the best," Swinney said. "We want to lead. We've been there, done that at Clemson as far as being reactive to everything. We want to be proactive. That's kind of the mentality that has taken root here."

When Bowden began his tenth and final season in 2008, his staff included nine assistant coaches, two graduate assistants, two video graduate assistants and two members of the football administration. Swinney's 2014 staff included eighteen support staff positions. Bowden's final support-staff payroll was $287,118. Swinney's 2014 support-staff salaries totaled $1.47 million. Included on his current support staff is director of player relations Jeff Davis, who played on the 1981 national title team. There's a director of football coaching technology (Todd Green). There's Brad Scott, a longtime assistant who now helps incoming freshmen make the transition to college

life. And there's Turnipseed, who has assembled a staff of forty that does much of the recruiting busy work that used to be done by coaches.

"Everything that used to be done in my office with maybe one student assistant has been replaced by Thad and his assistants that work back there all the time," said Scott, who served as recruiting coordinator for six years. "A lot of times I was doing wide receiver stuff and at lunch I'd go in for ninety minutes and do recruiting, then go to practice. At some point you're turning one off to turn the other one on. And recruiting had gotten so big that we needed someone to come in and do nothing but recruiting full time, and it's allowed us to really take that next step."

Turnipseed coined the term "Clemson Google" to describe his department.

> *We are really there to support the coaches. It's logistics support. Instead of seeing three or four players today, can we use the airplane because by the way we have some 2017 kids and some 2016 kids that will be hot two years from now? Why don't you swing by four miles to this school and just go ahead and touch base? So instead of seeing four kids a day, we might see six kids a day, and that will pay dividends two years down the road.*

In mid-October 2008, Swinney was trying to get through one of the most tumultuous and emotionally draining weeks of his life. Four days after an exasperating 12–7 loss at Wake Forest dropped Clemson to 3-3, Swinney learned that the man who had brought him to Clemson was gone. Then, a few minutes later, he learned he was the man chosen to guide the program for the rest of the season with a chance to keep the job if he won enough. That week, the day before Clemson played host to Georgia Tech, Swinney was called to a morning meeting with the board of trustees. The board members, most of whom he'd never met, wanted to voice their support for Swinney while disputing the perception that they didn't care about athletics. They told him they wanted to be more like Michigan, Georgia and Florida—three schools that successfully balanced achievement in academics and athletics.

"I'm sitting there, and in my mind I'm going, 'Well, this is going to be a short job interview right here,'" Swinney recalled. "I said, 'That's not my vision for Clemson. My vision for Clemson is for Georgia and Florida and Michigan to be more like Clemson.' I've never been interested in trying to worry about somebody else. Let's be the best we can be."

In the winter of 2010, NFL scouts flocked to Clemson's campus to watch star C.J. Spiller on the Tigers' Pro Day. Spiller put together a spectacular career as a running back and return man from 2006 to 2009 after Swinney

pulled off the remarkable feat of going into Florida and signing the decorated prospect. The weather was nasty outside for Pro Day as everyone assembled inside the aging track facility a few hundred yards from Lake Hartwell. NFL scouts were alarmed when the makeshift artificial turf was rolled out, showing dangerous bumps and creases that could have resulted in serious injury for Spiller and the rest of the pro aspirants. The scouts made the call to move the workouts outside, and Spiller went through his drills under torrential rains in an event that was supposed to be a showcase for one of the more important players in Clemson's history. Swinney was embarrassed, and that day was crucial in making the case for building an indoor facility for the football program. The structure was completed late in 2012, and during a rainy December, the Tigers used it extensively in preparation for a victory over LSU in the Chick-fil-A Bowl.

Two years later, Swinney had an idea for the new football operations facility, but he needed support. And a key figure on the board of trustees, former chair Hendrix, was a key obstacle. Hendrix couldn't understand why Clemson needed to spend more than $50 million on a new facility when the football program had just moved into the sparkling West End Zone facility a few years before. Swinney knew he needed Hendrix on board, so he flew to the Lowcountry and met with him at his home on Kiawah Island. He walked away with a $2.5 million check for the facility and the fundraising momentum he needed. Over the next six months, close to $20 million was raised. Ultimately, $35.5 million was raised for the 140,000-square-foot structure, which will include sand volleyball courts, laser tag, a movie theater, bowling lanes, a barbershop and other luxuries that appeal to current and prospective players.

"I'll tell you," Swinney said. "Some of the best deals are still done on the back porch. There's just something like a back porch, looking out at the ocean. But I went down there really not knowing what I was getting into. I mean, I've never asked anybody for $2.5 million before."

As Swinney tried to keep his emotions together at the groundbreaking ceremony, he told the crowd that every dream starts with a dreamer. He thought back to when Clemson couldn't get out of its own way, when everyone wanted to talk about how great it was back in the 1980s under Ford.

"When I got this job, everybody talked about the good old days… Everybody walks around like the best is behind us. I'm telling you, the best is yet to come. This is the good old days. This is the best of times. And what this facility does, what this facility means when we stick a shovel in the ground, what we're saying is the best is yet to come."

CLEMSON TOUGH

For a long stretch, Clemson was known as a good football program that had plenty of talent. Bring in a list of elite athletes that includes C.J. Spiller, James Davis, Sammy Watkins, Tajh Boyd, Andre Ellington and DeAndre Hopkins, and you're going to be able to play with just about anyone.

There was a fundamental deficiency, though, and it was illustrated fully in two games over a five-year span: 2008 against Alabama and 2012 against Florida State. In the former matchup, Clemson began the season ranked No. 9 and had all kinds of star power as it faced a team that had won seven games the year before in Nick Saban's first season. The Tigers never really had a chance, largely because they were physically overwhelmed by the Crimson Tide in a 34–10 dismantling that was far worse than the score indicated. That game marked the beginning of Saban's dominance in Tuscaloosa, and it marked the beginning of the end for Clemson coach Tommy Bowden. For all the glitzy skill guys who drew the preseason recognition for Bowden's team, they couldn't hold up at the point of attack against the Crimson Tide.

In the latter game, Clemson went to Tallahassee for a Top 10 showdown and was actually up 28–14 at one point as offensive coordinator Chad Morris emptied his bag of tricks with Boyd, Watkins, Ellington and Hopkins. But the Seminoles used brute force to take over, bulldozing the Tigers 49–37 while amassing 287 rushing yards. The second half of that game strongly suggested that Clemson was a finesse team that wasn't tough enough to close the deal against an elite, physically imposing power.

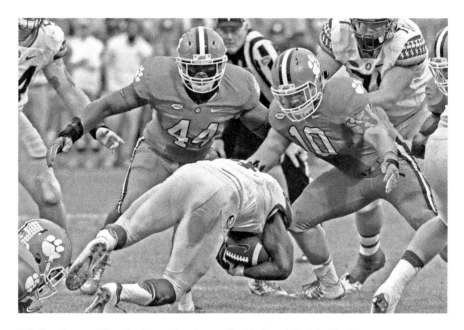

B.J. Goodson and Ben Boulware close in on Florida State's Dalvin Cook.

If Clemson was going to be a more consistent program, one that could hold its own in these sorts of matchups, it was going to have to supplement the glamour players with strong, disruptive linemen and linebackers. It was going to have to produce a defensive front that put up stiff resistance and an offensive line that could open holes when it had to. Later that year, in the Chick-fil-A Bowl against LSU, a young defense under first-year coordinator Brent Venables showed the first sign of what was to come by creating constant quarterback pressure and regularly stuffing the Bayou Bengals' powerful running game.

The next season, Florida State walked into Death Valley and hung a 51–14 embarrassment on the Tigers on the way to the BCS title as the Tigers fell apart with turnovers and uncharacteristic mistakes. In 2014, the Tigers went to Tallahassee and largely shut down Florida State's offense. But the Tigers gave the game away in part because of self-impaling mistakes and also in part because they couldn't run the ball in short yardage when they had to. The excruciating 23–17 overtime defeat might have been the most difficult of Dabo Swinney's coaching career because of just how much the victory seemed in the Tigers' grasp.

When Tony Elliott and Jeff Scott became the main offensive brain trust after Morris's departure for SMU, they told their players a lot of points had

been scored and records broken over the previous four seasons. Despite all that success, and plenty of big wins, Clemson was still trying to take the next step to a truly elite level. There was still something missing, and that something was a running game that could grind through opposing defenses.

"The last couple of years, we've had a lot of those third-and-one, fourth-and-one calls where we're just getting stoned and knocked back and that's really ended drives," Scott said.

Even in 2011 when Clemson was announcing itself as a force after a 6-7 season in 2010, the lack of a consistent running game ended up playing a big role in a late-season decline that followed an 8-0 start. In four of their final five regular-season games in 2011, the Tigers would rush for fewer than one hundred yards. That included losses to Georgia Tech (ninety-five yards), NC State (thirty-four yards) and South Carolina (seventy yards).

The 2013 and 2014 seasons were important for the defense because they showed that the Tigers had become a nasty group that could control the line of scrimmage against just about anyone. And though the 2015 defense was missing an assortment of weapons who made that upward progression possible, there was still plenty of confidence that the defensive line and linebackers had enough players who could disrupt and spend a lot of time in opposing backfields.

What was much less certain was whether the running game would be there. After the offensive line lost four starters from 2014, veteran center Ryan Norton went down with an injury after the second game. But the coaches believed all along that this group of freshmen and sophomores was an upgrade from what Clemson had been accustomed to over the years on the offensive line, highlighted by the February signings of celebrated freshmen Mitch Hyatt and Jake Fruhmorgen. The coaches observed that these two, plus a number of other linemen who had been with the program for two years or less, woke up every morning thinking about how to become better offensive linemen. The way they ate it, breathed it and slept it was a big difference from predecessors who might have had too casual an approach.

Jay Guillermo, whose football future was in doubt during the off-season when he left for several months to deal with depression, returned in August and stepped right in at center after Norton's injury. After a nondescript career, fifth-year senior Eric Mac Lain blossomed at left guard. Joe Gore, Taylor Hearn and Maverick Morris also supplied key contributions as the offensive line became a foundation instead of a weakness. Swinney said before the season that the offensive line would be a strength by the end of the year, but the progression was far more accelerated than anyone envisioned.

Entering the ninth game against Florida State, the No. 1 Tigers were averaging 218 rushing yards a game. A week earlier, in a wild 56–41 win over NC State on Halloween night, the Tigers churned out 240 yards on the ground with eight carries of 10 yards or more. Redshirt sophomore Wayne Gallman had become the violent, rampaging running presence the staff had seen glimpses of over the previous couple years in practice. For four years, Morris fantasized about having a punishing between-the-tackles running game that would set up a play-action passing game and truly make his offense go. A year after Morris's last offense at Clemson produced 146 rushing yards a game, his vision was coming to fruition as the combination of the run and pass was making Clemson's offense a nightmare for opposing defenses.

"Ain't a whole lot more fun than getting to drive someone off the ball," Guillermo said. "With everything that we do on the perimeter, you can't do it all if defenses don't expect you to be able to run the ball in the middle. Every great team that you ever see can really drive the ball down the field, and that's what we're really trying to do. Especially as an offensive line, we take pride in it. Me and Eric, late in the fourth quarter of games are begging Coach [Robbie] Caldwell to let us go back in so we can get two-hundred-plus yards rushing. It's something that as a great team you've got to do."

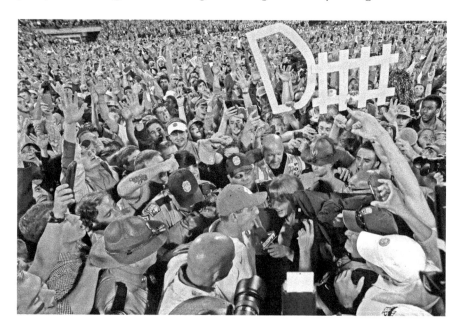

The celebration on the field after Florida State.

Ohio State's late-season run to the 2014 national title reinforced the message that it all starts with a dependable running game. For all the new-age bells and whistles of Urban Meyer's offense, the Buckeyes ran for 301 yards against Wisconsin in the Big Ten title game, 281 against Alabama in the semifinal and then 296 against Oregon in the championship.

After NC State hit for a surprising number of big plays in Raleigh, Swinney told his players this game against the Seminoles would be decided by who won in the trenches. And that was exactly what happened as the Tigers ran for 215 yards while keeping Florida State out of the end zone over the final fifty-nine minutes in a 23–13 win that signaled a changing of the guard atop the ACC. After losing to Florida State three straight years and four of the previous five, Clemson knocked off its nemesis and solidified the No. 1 ranking it had been granted earlier in the week. A year earlier, the Tigers had surmounted one large obstacle when they finally beat South Carolina after five straight rivalry losses. Now Swinney's team took care of the Seminoles, who entered the game as double-digit underdogs but gave plenty of fight.

"We knew they weren't going to give it up easy," Swinney said. "They played their butts off. It was just our time."

It was the Tigers' time because they had developed enough as a program where they could win the battles up front. Gap-control issues on defense, which appeared several times at NC State, recurred in the first minute against the Seminoles as star tailback Dalvin Cook dashed seventy-five yards for a touchdown to suck the life out of the stadium. Clemson even found itself in the rare and uncomfortable position of being down at halftime, 10–6, after Deshaun Watson mistakenly spiked the ball near the goal line on third down to force a field goal.

But Cook rushed for just thirty-seven yards after halftime, and the game's defining moment was when Florida State was in Clemson territory in the fourth quarter and trying to drive for the go-ahead score. On third-and-one, Cook took a toss right and was smothered by B.J. Goodson for no gain. On fourth-and-one, he took a toss left and Shaq Lawson forced him inside for Ben Boulware, who stopped him short of the marker as the stadium unleashed an avalanche of noise. These were not plays Clemson was physical enough and tough enough to make often under Bowden and even some early in Swinney's tenure.

Up 16–13 and facing two key third downs, Elliott made two excellent play calls by running tunnel screens to Charone Peake. Gallman broke through on a powerful, relentless twenty-five-yard touchdown run that put

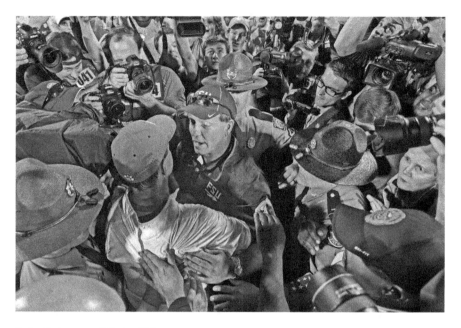

Dabo Swinney and Jimbo Fisher.

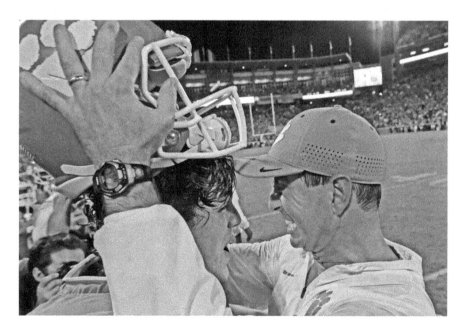

Dabo Swinney and former walk-on Jim Brown.

Clemson up two scores with 2:34 on the clock. Moments later, Boulware would extend his powerful left arm into the side of Travis Rudolph to rip the ball out after the Seminoles receiver advanced to midfield. Clemson recovered the fumble, and the party was on as the Tigers improved to 9-0 with a trip to Charlotte and the ACC Championship game sealed.

Even with all those new and inexperienced offensive linemen, the Tigers were still able to run the ball against a really good defense. Even after losing linebackers Stephone Anthony and Tony Steward and all those defensive linemen from 2014, the Tigers were still nasty on defense when they had to be. It was a lot like the Notre Dame victory in the way the defense dug deep and showed its guts by producing game-changing stops.

"We're built for that," Goodson said afterward. "We're built for situations like that. That's what we work hard for. I tip my hat to offenses who try to do us like that, trying on third-and-one and fourth-and-one running the ball. We're built that way."

At midfield after the game, Florida State coach Jimbo Fisher told Swinney to "go win the whole thing." On this night, the Tigers looked like they were built to do precisely that.

CHAPTER 8
BIG MAN ON CAMPUS

It was the dead of a Connecticut winter, and Charlie Cahn was worried no one would show up to his school's ninth-grade basketball game.

As the headmaster of Suffield Academy, Cahn worries about these types of things. So on this particular day earlier this year, he took his ten-year-old son to the gym to show some support. There, amid a cluster of ten or twelve people who included mostly parents, was a familiar face: Christian Wilkins, senior three-sport star, the biggest man on campus literally and figuratively, the person Urban Meyer and David Shaw and Dabo Swinney and a bunch of other major coaching names had traveled there to recruit.

"Nobody shows up to those games," Cahn said. "Christian had a varsity basketball game later that night, so he could have been sleeping or hanging out with his friends. We walk in and he is sitting there in the first row, cheering on the team. He knows every kid on the team."

If the conversation about Wilkins is athletics alone, he boasts quite the portfolio. He surpassed one thousand points during his high school basketball career. He was an accomplished member of the track team, distinguishing himself in the discus, shot put and javelin. And yes, he was a certified monster on both defensive and offensive line as he did some of the same things Clemson fans saw during his freshman season with the Tigers in 2015. Wilkins probably would have started right away for many other teams, but Clemson's interior defensive line was so stacked with talent even after losing three seniors from 2014 that he had to come off the bench. He made his presence felt from the beginning, though, regularly pushing linemen into

Christian Wilkins on a visit to Suffield Academy.

the backfield and making life difficult for quarterbacks and running backs. He was named freshman All-America by the *Sporting News* in December after totaling seventy-two tackles in 385 snaps over thirteen games.

"Just last year I'm playing in high school, playing for high school championships, and now I'm at the collegiate level playing for it all," Wilkins said in December. "I've just been truly blessed to this point in my athletic career."

When you talk with people at this boarding school whose lives were affected by Wilkins—and that's pretty much everyone—they don't start with the athletic achievements that attracted the aforementioned procession of coaches. That stuff is just a footnote.

"I wouldn't be surprised if he's on the board of trustees here one day," said Cahn, headmaster for twelve of Wilkins's twenty-two years at the school. "This is a great, great school. But it's slightly weaker when Christian is not here. And I'm sure the same will be true in three or four years at Clemson. I bet at Clemson they can't believe it. I'm sure they're thinking, 'Who is this kid?'"

When Clemson was strongly in the mix for Wilkins's letter-of-intent signature, everyone knew the six-foot-three, 315-pound kid from Connecticut was going to be a special player. But almost no one knew what he was

thinking, and it drove fans crazy. Almost every decorated prospect loves the recruiting process because the process brings publicity. Reporters are writing stories about you. Maybe they're even talking about you on ESPN. Fans are bombarding you with worship on social media. It's a heck of an ego boost for an eighteen-year-old who feels like he can do anything.

Wilkins wanted none of it. He wouldn't tip his hand to recruiters, reporters or even those closest to him at Suffield Academy. The silence brought mystery and, with it, the mistaken conclusion from afar that this Wilkins kid must be a strange bird because he didn't return calls or give any indication which way he was leaning. The truth? Wilkins wanted to be like all the other 410 students at this co-educational secondary school he called home for almost four years. He wanted nothing to do with the celebrity that most hotshot recruits welcome. He wanted to be just another guy.

The athleticism and the strength and the body control and the great feet are what drew Swinney, Brent Venables and Dan Brooks to Suffield. But what made them truly fall in love with the kid was not what they saw between the lines or on a statistics sheet.

"The more you got to know him, the more you got to know the people around him and what they thought of him," Venables said. "That's what continued to humble you as you were recruiting him. You're just like, 'There's no way we're going to get this guy. It's just too good to be true.' We kept fighting and all that in recruiting, but I was like, 'This guy ain't coming to Clemson.' He's that guy where the glass is always half full. He's got a lot of things in his life that have happened to him where he could have went the other way."

Childhood for Wilkins was not easy. He was the youngest of eight siblings (four boys, four girls) raised by their mother in Springfield, Massachusetts, about twenty minutes north of Suffield. Times were often tough as mom struggled to pay bills and even find clothing for her kids, who now range from ages nineteen to thirty-two. In January 2011, the family was devastated when its sixty-seven-year-old grandfather was shot and killed by a SWAT team at his home in Framingham, Massachusetts. According to a DA investigation, Eurie Stamps died after a SWAT team officer's gun mistakenly discharged. The SWAT team stormed into the home looking for the son of Stamps's wife, and Stamps was killed while lying facedown in the hallway of his home. Last January, a federal judge in Massachusetts ruled that the family could bring a lawsuit in the case—but only toward the officer who shot Stamps and only for compensatory damages.

The fallout and the controversy from the shooting was highly public, and at the time Wilkins was living with relatives in Framingham. He had

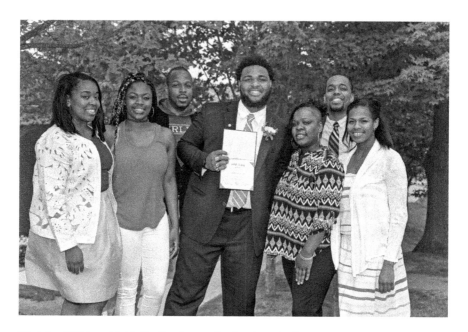

Christian Wilkins with his family after graduation from Suffield Academy.

to continue going about his daily routine as a public high school freshman as the story made headlines in the Boston community and beyond. When Wilkins announced his commitment to Clemson in January 2015, he chose the four-year anniversary of his grandfather's death to break the news.

Athleticism runs in Wilkins's family, from his father to his brothers and sisters. But when you ask where he acquired his extraordinary charisma and ability to relate to almost everyone, they tell you that came from his late grandfather. Add to that growing up with four older sisters, and you start to understand how he developed into such an inspired, inspiring figure.

"Early on, he may have developed a little faster than others because he had to catch up to everyone else," said Drew Wilkins, his twenty-eight-year-old brother who teaches public school math in Springfield. "Even as a younger kid, he always looked up to his older siblings. His sisters were like second moms. So he has tremendous respect for females in general because of that."

The aftermath of Stamps's death was a major factor in Wilkins moving back to Springfield from Framingham, which is about forty minutes outside Boston. He ended up at Suffield Academy after a visit there with his godparents, Robert and Lynne Krushell, two other important influences in his life.

Suffield Academy was founded in 1833 and prides itself on a family atmosphere. Students come from across the country and the world; Cahn said its enrollment of 410 includes students from nineteen states and thirty-five countries. Dress code for boys is blazer, button-down shirt, tie, slacks with a belt and dress shoes. Full-time boarders live in thirteen dormitories and follow a regimented schedule: school is from 8:00 in the morning until 3:00 p.m., sports from 3:30 to 5:30 or 6:00 p.m., dinner from 6:30 to 8:00 p.m., studying in your room from 8:00 to 10:00 p.m. and lights out at 11:00 p.m.

Wilkins didn't just blend in or settle for a reputation as a jock. Almost immediately after he transferred to Suffield during his freshman year, he made a profound impression on coaches and faculty.

The Suffield Tigers football program has a tradition of winning under Coach Drew Gamere. They excelled before Wilkins's arrival, and they continue to after his departure. In 2015, they made their eighth consecutive appearance in a New England prep-school championship bowl game. The biggest impression Wilkins left on Gamere is not his extraordinary athletic gifts—the cartwheels into back flips, the ability to dunk off both feet, the double front flips off the diving board at the swimming pool or the countless instances of him terrorizing the opposition. Even when Wilkins was a big-ticket item for the biggest and best college programs, he wasn't too big to stand on the sideline of JV football games with water bottles in hand for timeouts.

"He embraced everybody and everybody embraced him," Gamere said. "He obviously had a lot of talent, but you don't know at first what you're getting with some of these talented guys. He was just so coachable right away. We stress that every man matters, whether you're the top player or the guy that isn't going to play at all on Saturdays. Christian really bought into that."

Wilkins, who has family in Rock Hill, said he liked Clemson from an early age. But his visit to campus in November 2014 sealed his convictions that this was the place for him. It was not just the ten-win seasons and the growing list of big wins and all that orange but also the community and the family vibe and the feeling that he'd be more than just a football player.

"I think he was looking for an environment similar to here," Gamere said. "He was looking for extended family, people who cared about him and people he could care about."

Wilkins arrived on campus in the summer of 2015, electing against enrolling in January with a bunch of other freshmen. He wanted to finish

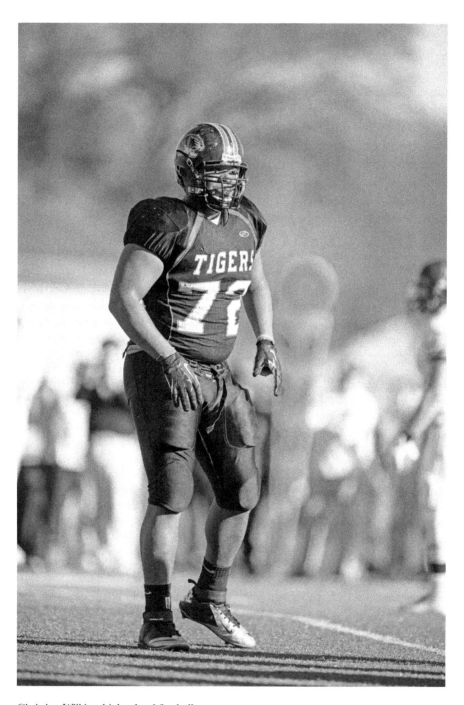

Christian Wilkins, high school football star.

out his high school career at Suffield like a normal student would, going through all the traditional activities and ceremonies. At commencement, he received an honor that had zero to do with athletics. Cahn, the headmaster, said the Ap Seaverns Award goes to "the senior who best shows a sense of pride, loyalty and determination spiced by a keen sense of humor." Wilkins also won the Butler Cup award, given to the finest athlete in his class. He told Cahn that the Ap Seaverns Award meant more to him.

"Christian's absence as a football player is not where we felt it the most," Cahn said. "Where we felt it is as a community."

On a Friday morning in late September, Gamere was grinding away in preparation for his team's season opener. In through the office door bounced Wilkins, unannounced as he made a trip back home on Clemson's open date. He spent that day at the school, introducing himself to freshmen he didn't know and sitting in the dining hall and student union, just like before. He was not Christian Wilkins, returning celebrity. He was Christian Wilkins, regular dude.

Said Cahn: "It was as if he had never left."

This big nineteen-year-old, with all that size and all the athletic ability in the world, has every reason to act like a big deal. But he never has. And probably never will. He's always been big for his age. Big person, bigger personality.

"Regardless of what he does in football," Cahn said, "I have no doubt he's going to have a huge impact on the world."

CHAPTER 9
SUPERHERO STORY

Anyone who knows anything about Dabo Swinney knows he is an optimist almost to a fault. But on a Sunday afternoon late in November 2014, the man was an avowed skeptic.

Six days before a visit from Steve Spurrier and South Carolina—and a mere three days after suffering a torn ACL in practice—Deshaun Watson walked into Swinney's office with head trainer Danny Poole and said something Swinney could not comprehend. Watson fully believed he could play against the Gamecocks. Furthermore, Poole was backing him by saying Watson wasn't in danger of injuring the knee any further before the planned surgery in December.

The Tigers had just taken care of Georgia State, and the coaching staff had turned its attention to a South Carolina program that had dealt Clemson all kinds of heartache with five straight wins in the rivalry. It was proceeding with the Cole Stoudt game plan, not even considering that No. 4 might be an option.

"I had already kind of mentally moved on," Swinney said. "Even with what Danny Poole told me, I wasn't very optimistic. But Deshaun was kind of pressing the issue."

On that crisp November afternoon against the Gamecocks, a freshman who was playing high school ball a year before managed to put an entire program on his back—and one leg—while chasing away all those demons as the Tigers secured an exhilarating, therapeutic 35–17 victory over their rival. They had won forty games since the start of the 2011 season and had a lot of unforgettable moments, but they couldn't beat South Carolina, and now

Watson was making it look easy against a Gamecocks team that had slipped in year ten under Spurrier. After the game, people gasped when Swinney revealed Watson had played on a torn ACL. Thus, a remarkable performance became an almost superhuman performance that will never be forgotten.

"We all know how special he [Watson] is and what he means to that program and the university," said former offensive coordinator Chad Morris, who coached his last game at Clemson that day before leaving for SMU. "I thought that was as gutsy and as courageous a performance as I've been around, especially when you looked at the record. It's not like Clemson was 5-0 against them. They were 0-5, and this was a critical game."

Often it takes the passage of time for a narrative to fully develop and crystallize. In 1980, when a mediocre Clemson team threw on the orange pants and shocked everyone by knocking off a powerful South Carolina team, no one was saying it represented the turning point to something special. The Tigers went on to win the national title in 1981, and that spirited victory over the Gamecocks a year earlier was viewed as a landmark, pivotal moment only in hindsight.

Maybe Clemson fans will look back at November 29, 2014, with the same reverence and wonder. It's conceivable that the Tigers could have won the game against a mediocre Gamecocks team without Watson. It's conceivable that they could have gone on to have a special season in 2015 regardless of what happened that day against the garnet and black, the visor and the school that tormented it so much from 2009 to 2013 with double-digit victory margins all five years.

What happened that afternoon didn't necessarily facilitate what happened the next season. But it provided momentum for a tenth victory clinched in the bowl game against Oklahoma, even with Watson out mending a surgically repaired knee. And a year later, as Clemson went for a perfect regular season against the woeful Gamecocks in Columbia, the presence of Watson provided plenty of confidence that the Tigers could make the plays when an anticipated blowout became way too close for comfort in the fourth quarter.

"That was a pivotal game because of what happened in the past," Morris said of Watson's 2014 performance.

The most interesting part of the run-up to the 2014 game was that maybe five people knew Watson had torn his ACL a week earlier during a Thursday practice for Georgia State. Five days earlier, at Georgia Tech, everyone was despondent when Watson went down with what was initially believed to be a torn ACL. He had returned after missing the better part of four games with a broken hand, and the offense was unstoppable against the Yellow Jackets with him in the game. After he left with the injury in the first quarter, the

Tigers lost the momentum and fell 28–6. The next day, an MRI showed that it was merely an LCL sprain and a bone bruise. Everything seemed all good until he tweaked it again that Thursday on the final practice before Georgia State. The next day, an MRI showed the ACL was torn, and it appeared Watson was done for the year.

When Watson walked into Swinney's office with Poole, making the case to play against South Carolina with a special knee brace, Swinney said he'd have to see more in practice Monday and Tuesday before taking the notion seriously. Poole pointed out to Swinney that former Tigers quarterback Tajh Boyd had played an entire season on a torn ACL in high school, winning a state championship and earning MVP honors in the U.S. Army All-America game. Still, Swinney wasn't buying in until he saw Watson on the field. Taking second-team reps on Monday, Watson looked OK, but Swinney was still cautiously optimistic. Then came Tuesday.

"I walked off the field after the Tuesday practice and was like, 'Wow, he had no issues,'" Swinney said. "I mean he was running around, doing everything. All the drill work."

That's when the decision was made to give Watson first-team reps at Wednesday's practice. It's when Swinney and Morris realized that the prospect of Watson playing against South Carolina was a very real thing. Swinney and Morris huddled with Watson, who preferred to keep his injury a secret. If word got out that he was going to play on a torn ACL, it would have become a sideshow and probably a full-blown controversy as pundits moralized about putting a player at risk of further injury.

"We had talked to his mama," Morris said. "Everybody was on board with it. If we didn't keep it a secret, it would have turned into the topic of discussion all week for him. And he would have had to answer it over and over and over. So it was best that just a select few knew, and we game-planned accordingly."

Game-planning was tricky. There was still a great deal of uncertainty about what Watson could do and how long he would last, so Morris came up with two completely different attacks for the Gamecocks: one with Watson and one with the struggling Stoudt.

"You kind of go back and forth," Morris said. "Then you just try to structure. You find out he's playing and you say, 'OK, he's obviously going to be limited.' You can't use him in a capacity that's full-stride like we would normally plan on. So we had to be a little bit more creative in some areas. That's why you saw us flank him out, move him out and move him around but yet still keep him on the field."

The most enduring moment for Swinney was late in the second quarter, Clemson up 14–7 and at the Gamecocks' ten. Watson rolled right, looking quite gimpy and looking for an open receiver before *exploding* through tacklers to the one-yard line. He took it in from a yard out on the next play to put Clemson up by two touchdowns. Clemson hadn't cracked 17 points against the Gamecocks since 2008, when Swinney was still an interim coach. They had 21 at the half thanks in large part to Watson. A year later, Swinney still can't quite fathom what he saw during and after that play from a player who had a blown-out knee.

"He sticks his foot in the ground and rockets through—runs right through. I'm literally on the headset going, 'Well, that's it. Go get the stretcher.' But he just pops up and runs off. It was just amazing to me. The burst, it was just instinctive for him. He didn't even think about it. He pops up and comes over there and I'm like, 'Are you OK?' He's like, 'Yeah, I'm good.' I'm telling people: This guy is just from another planet."

About forty-five minutes after the game, Swinney opened his press conference by informing reporters his freshman quarterback had just played the game on a torn ACL. Players had gone off to celebrate with family and friends at tailgates, many hearing the news about Watson's knee outside the stadium at those gatherings. They were as shocked as everyone else.

"I knew that with him on the field, he gave us a sense of confidence," said Morris, who was off for SMU the next day. "He gave everybody a sense of confidence."

A year later, Watson and the Tigers' offense had generated supreme confidence heading into the rivalry game at Williams-Brice Stadium. Clemson had suffered from some defensive glitches over the previous month as it dealt with depth issues and fatigue, but it didn't matter because the Tigers were basically unstoppable on offense.

After some early sputters that included lost fumbles by Wayne Gallman and Watson, the offense found its groove. The Tigers entered halftime up 14–3 after a five-yard scoring run by Watson and a beautiful deep ball to Deon Cain on a fifty-five-yard touchdown connection. Clemson got the ball to start the second half and motored right down the field again, sealing it with a thirty-yard touchdown run from Watson that featured him soaring in to kiss the pylon with the ball in his outstretched arms.

South Carolina answered to make it 21–10, but Clemson answered right back with an authoritative touchdown drive to put the Gamecocks in a 28–10 hole. Gamecocks fans, who had watched their team lose to The Citadel a week earlier, began heading for the exits. But then crazy things started happening. The defense failed to cover the Gamecocks' best player,

and Pharoh Cooper made them pay with a fifty-seven-yard touchdown catch-and-run. Then Artavis Scott lost a fumble, allowing the Gamecocks to turn around and capitalize with a short twenty-six-yard touchdown drive. Suddenly, after a successful 2-point conversion, an 18-point lead had become a 3-point lead at 28–25. The home fans were in a frenzy, sensing a very real opportunity to ruin Clemson's perfect season.

Plenty of other quarterbacks would have melted in that situation. Other Clemson quarterbacks *did* melt in that situation in previous years, albeit against much better Gamecocks teams that were perennially in the Top 10. But Watson is not like most quarterbacks, and he showed it with an almost startling calm in guiding the Tigers down the field for a score that enabled the orange-clad fans to breathe again with a two-score lead.

On third-and-nine from his own forty-one, Watson coolly navigated the pocket and went to Jordan Leggett on the sideline for a gain of thirteen. On another third down, this one from the Gamecocks' thirty-three and needing seven yards, Watson uncorked a dart to Trevion Thompson on the sideline—just beyond the fingers of a defensive back—for a gain of twenty-four. And finally, on third-and-goal from the three, when a field goal would have kept it a one-score game, Watson took it in himself on a touchdown run that made it 34–25 with eight minutes left.

Adrian Baker with a big interception deep in Clemson territory at South Carolina.

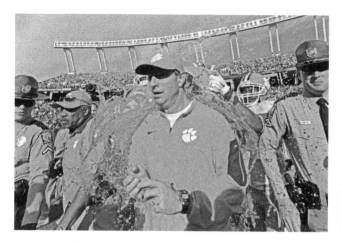

Dabo Swinney gets a bath after back-to-back wins over the Gamecocks.

The offense surpassed 500 yards for the eighth consecutive game, and Watson again was the biggest part of it. He completed twenty of twenty-seven passes for 279 yards while rushing for 114 yards and three touchdowns on twenty-one carries. The Tigers had their perfect regular season, plus the satisfaction of watching the hated Gamecocks close their year with a 3-9 record under interim coach Shawn Elliott.

Clemson fans walked a way a bit uneasy after those tense fourth-quarter moments. They came hungry for a massacre, perhaps similar to the 63–17 annihilation that the 2003 team administered on the same turf, so a 5-point victory was less than thrilling. And if not for No. 4, they might well have walked away with the most painful loss in school history.

The story of this game, and much of Clemson's season: the Tigers have Deshaun Watson, and opponents don't.

"He is an awesome young man and an awesome competitor," said co-offensive coordinator Tony Elliott. "We told him we were going to put the ball in his hands. We believe he's the best player on the field, the best quarterback in the country. And he continues to produce. It seems like the hotter the fire, the stronger he gets."

Even on one leg a year earlier with his team desperately needing to snap the Gamecocks' streak.

"It was amazing," Swinney said of Watson's 2014 heroics. "They'll be talking about that one a long time from now."

CHAPTER 10
THICK CRUST

On November 3, Dabo Swinney and Clemson were trying to focus on a visit from Florida State four days later. The focus of plenty in the media, however, was the unveiling of the first College Football Playoff ranking later that night. As Swinney stood at his weekly Tuesday press conference in the team meeting room of the West End Zone, he was peppered with questions about the importance and meaning of Clemson as a prominent part of the poll. The Tigers were 8-0 after a 56–41 win at NC State, so it was considered possible that the Tigers would be ranked No. 1.

Predictably, Swinney said none of it mattered because the season was still in progress and it would all be irrelevant if the Tigers lost a game. Unpredictably, he promised a celebration if his team was in the mix for the final regular-season poll that would be released on December 6.

"It just has nothing to do with us," he said. "I mean, we're honored. What we're excited about is we've had a great season. That's what we're excited about. But the only poll we're excited about is December 6. And I promise you: we'll have the biggest poll party you've ever seen. We'll open up Death Valley and serve pizza to everybody and just have a poll party on December 6. That'll be a time to celebrate a poll. But until then, it just doesn't matter. Because man, you've got to earn your way there. You've got to win the games. You don't get any passes."

Less than a month later, no one on the team was preoccupied with pizzas as the Tigers shifted their focus to a showdown with North Carolina in the ACC championship. The Tar Heels had ripped through their schedule

Shaq Lawson gets to North Carolina quarterback Marquise Williams.

after an opening loss to South Carolina, winning eleven straight games and moving up to No. 10 in the CFP poll. Larry Fedora's offense had fully blossomed in his fourth year at the school, and an assortment of elite skill players made people at Clemson nervous. Not many teams were going to be able to slow down Deshaun Watson and the Tigers' offense, but the Tigers' defense was responsible for a disturbing trend of hiccups over the final month of the season.

Brent Venables's group had opened the season with a fury, defiantly showing that Clemson could still play elite defense after losing so many great players from the season before. They had come up with the defining stops against Louisville, Notre Dame and Florida State. But where there was a drop-off from 2014 was in the depth behind the front-line players. A year before, Venables and his assistants could rotate as much as they wanted with very little difference between the starters and backups. They didn't have that luxury this season, with little depth behind Ben Boulware and B.J. Goodson at inside linebacker and behind Shaq Lawson and Kevin Dodd at defensive end.

Problems with gap control and poor run fits surfaced at NC State, which had four runs of 20 yards or more. They popped up again early against

Florida State and Dalvin Cook, and then Syracuse ran wild with the shotgun triple option in amassing 242 yards on the ground. South Carolina had nine carries of 10 yards or more the week before in Columbia. It was a startling sight for a defense that had limited Georgia Tech to a mere 71 rushing yards earlier in the season.

Venables acknowledged that maybe he erred in not rolling the dice and inserting some of the untested backups on a more regular basis during the season. He acknowledged that the undefeated record and the No. 1 ranking and all the love from the outside might have taken away some of the edge that made his defense dominant earlier in the season.

"I think our guys are trying to hurry and get to the end instead of hurrying and get to the next play, the next meeting, the next practice," Venables said. "We've got to do a better job of our leadership coming out with better intensity. We haven't been getting better the last couple weeks defensively, and that's very concerning and disappointing."

When the schedule was released in January, everyone looked at the open date that preceded the showdown with Notre Dame and thought about how crucial the extra preparation would be for the Irish. Not many people thought through the nine straight weeks of football that came after it. Add in a tenth consecutive weekend with the ACC championship in Charlotte, and the cumulative effect was an issue for the defense.

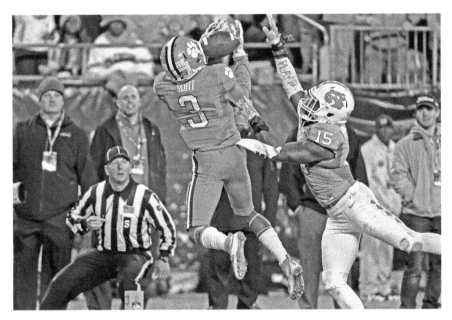

Artavis Scott with a big touchdown catch from Deshaun Watson.

In 2014, the defense was playing its best at the end of the year when it held Georgia Tech's powerful offense to a mere two touchdowns, shut down a prolific South Carolina offense and destroyed Oklahoma's offense in the bowl game. The fuel for that was extraordinary depth, which made for a bunch of fresh players in late November and December.

Junior safety Jayron Kearse recalled being "exhausted" by the eighth game of 2015 at NC State, just a week after the 58–0 destruction of Miami. He and others suffered from "dead legs," and he said opposing offenses capitalized "on guys being a bit slow because of I guess physical things."

"It's been a long season, a ten-game stretch," he said. "Guys are just hurting. Guys' legs are hurting. We haven't really had that opportunity to get a long period of rest. And it's just taking a toll on the guys. It's been kind of crazy. The first part of the season, guys were coming in and feeling good and everything was all good. It's just taken a toll on the guys now. Coaches are going to do their part in making sure we're healthy going into the game. And we have to do our part."

Among the injured was Boulware, who had played almost all the snaps during the season because of a lack of confidence in backup Jalen Williams. He was dealing with a shoulder injury that was so painful it necessitated four cortisone shots over the course of the game at South Carolina. The thought of Boulware basically playing with one arm against North Carolina sent shudders through Clemson's fan base because the Tar Heels had the speed and athleticism to exploit such a weakness.

The aches and pains weren't just on the defensive side of the ball. For weeks, star receiver Artavis Scott had been dealing with a sore knee that would require minor scope surgery in December. He hadn't been his normal powerful, explosive self in some time. Also, Wayne Gallman was battling a sprained ankle that left him at less than full strength against the Gamecocks. Freshman receiver Ray-Ray McCloud had sat three straight games after suffering a knee injury against Florida State, and right guard Tyrone Crowder was dealing with a case of turf toe.

In the days leading to the Top 10 clash with North Carolina, the theme in Clemson's locker room was: Dig deep and give everything you have Saturday. Then rest.

On Tuesday of championship week, Clemson remained No. 1 in the CFP poll, but selection committee chair Jeff Long revealed that there was extended debate among the committee members about making Alabama No. 1. This produced the logical conclusion that the Tigers would drop from the top four of the rankings with a loss. Thus, it seemed quite likely that after

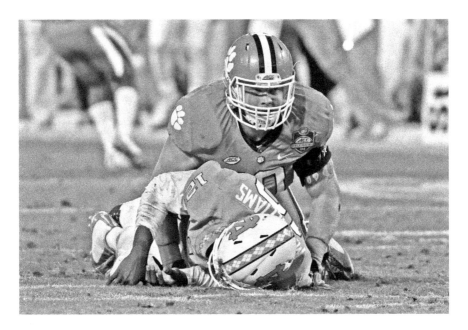

Ben Boulware brings down Marquise Williams.

all it had accomplished, Clemson could lose a shot at the national title with a slip against North Carolina.

The Tigers had committed ten turnovers in their previous three games, and six giveaways against Syracuse and South Carolina allowed the Orange and Gamecocks to stay close in those games. The feeling among the coaches and players heading to Charlotte was that the Tigers were going to be hard to stop if they protected the football.

The biggest question was whether Clemson would be able to slow down an offense that had torched just about everyone it played in the month of November. Clemson had the 58–0 evisceration of Miami, but North Carolina put up 59 on the Hurricanes. A week before in Raleigh against NC State, the Tar Heels scored 35 points in the first quarter before winning 45–34. Quarterback Marquise Williams was the trigger man of a fast-paced spread offense that had a number of elite weapons, including Elijah Hood, Mack Hollins, Ryan Switzer, T.J. Logan and Quinshad Davis.

But most games come down to the lines of scrimmage, and Clemson's staff believed the Tigers could control the game if their defensive line won individual battles and created havoc in North Carolina's backfield. That's exactly what happened on this night at Bank of America Stadium, as Clemson's front turned Williams into a jittery, frazzled mess. If Williams

wasn't getting pressured or sacked, he was throwing passes high or wide of open receivers. Combine that with a Clemson offense that found a groove late in the first half, and it was hard for the Tar Heels to keep up as they totaled six three-and-outs.

Even on the first drive of the game, when North Carolina was scooting down the field with ease, Shaq Lawson made a lasting impression when he planted Williams into the turf as the quarterback unleashed a pass.

"The first play when I got the big hit on him, I know he felt it a lot," Lawson said. "So I knew we had to hit him all game. We couldn't have him comfortable in the pocket."

Some late defensive lapses allowed North Carolina to cut into the margin and make for some tense moments, including a controversial offside call on an onside kick that the Tar Heels recovered. But Clemson walked away with a mix of elation and exhaustion as it celebrated a 45–37 win on the buses back to campus in the wee hours of Sunday morning.

The offense turned it over just once and once again was led by Watson, who threw for 289 yards and three touchdowns while running for 131 on twenty-four carries. So the Tigers would have been hard to beat on this night regardless of the way the defense played. There was no doubt as to the superior team, in large part because the defense dug deep once again when the stakes were highest.

"I love the guts and I love the heart of this team," Swinney said after his team improved to 13-0. The Tigers became the lone undefeated team remaining in college football when Michigan State drove to defeat Iowa in the Big Ten title game.

"We talk all the time about you've got to be a champion on the inside before you can be a champion on the outside, and tonight the inside of these guys really shined through."

And now, finally, it was time to celebrate the poll. After the caravan of buses arrived at Death Valley around four o'clock the next morning, Swinney and his team would return hours later for a pizza party scheduled to begin at eleven o'clock with the selection show broadcast on the big screen above The Hill on the east end. An estimated thirty thousand fans flocked to the stadium for free pizza, most of them sitting in the south lower deck as the team filed onto the field. Swinney took the microphone and noted that they weren't putting on celebrations that remotely resembled this one in Norman, Tuscaloosa or East Lansing.

"Only in Clemson do you have a day like today," he said before the semifinal pairing with Oklahoma was announced.

Dabo Swinney and the Tigers watch the big screen at the poll pizza party.

An estimated thirty thousand fans showed up for the poll pizza party the morning after the ACC title game in Charlotte.

Back on November 3, Swinney had made the promise of this event if his team kept winning. Athletics department staffers cringed at the time because they knew the logistical challenges of cranking out 2,500 pizzas and serving everyone on a Sunday morning after a game two hours away.

"I created some stress for a lot of people," Swinney said. "But I felt like our players and our fans needed to be celebrated."

A lot of work went on behind the scenes to make it happen, but the fans showed and the team showed, and it all just sort of came together in a special way that perfectly fit a special season. The night before, Swinney had opened his postgame address to the team by acknowledging the Final Four run by Mike Noonan and the Tigers' men's soccer program. He did the same thing during the pizza party as everyone cheered.

Up in the press box, Swinney was chatting with reporters after the fans had filed out. He reminded the media that the fun can be in the winning for them, too.

"You may not follow another 13-0 team," he said. "Have some fun with it."

Clemson was No. 1 wire to wire, and it still felt so new and so exciting to a team and a fan base that wasn't accustomed to such prominence. Next stop: Orange Bowl.

"We're just getting going," Swinney said.

HOME GROWN

Last year, Lee Wiley traded in his red-and-black Hummer for an orange Jeep Wrangler.

Wiley says he didn't specifically make the color change based on his allegiance to Deshaun Watson, but he acknowledges the possibility that his mind might have subconsciously steered him toward the Clemson color. Whatever the case, the sight of a Georgia grad and lifelong Bulldogs fan riding around Gainesville, Georgia, in an orange vehicle perfectly captures the inner conflict that's unfolded in this town since it was evident Watson was not going to end up in Athens.

"As Bulldog fans, we'd love for Deshaun to have gone to Georgia and are kind of still mad at the coaching staff that he didn't," said Wiley, fifty-four, who coached Watson's eight-year-old pee wee team back in 2003.

This community of thirty-four thousand is known for its poultry production and for its allegiance to the Georgia Bulldogs. Not necessarily in that order. The school colors at Gainesville High are red and black. Forever, the Red Elephants' football helmets have been adorned with the same "G" that's on Georgia's helmets.

The people here are still trying to figure out how Watson, one of the most decorated high school players in Georgia football history, is not carving up defenses forty-two miles away in Athens. In other parts of the Peach State, Bulldogs fans spent December 2015 lamenting the school's parting with longtime coach Mark Richt. The man won a lot of games, and he was first class all the way. The way his recent ouster was handled makes a lot of

people uncomfortable. Here, not so much. In Gainesville, where Georgia's coaches took only a passing interest in Watson until it was too late, they think Richt's firing was justified because of the staff's indifference to a superstar who was sitting right under the Bulldogs' noses.

"People are livid," said Michael Perry, a Georgia grad who started coaching Watson in the eighth grade. "Because everybody knows he could be doing all this stuff with a 'G' on his helmet, just like he did here."

The story of Watson's life and his upbringing were chronicled plenty in the summer and fall of 2015. ESPN and *Sports Illustrated* documented how his mother, Deann, raised her four children in a rough part of town before a house built by Habitat for Humanity allowed them to escape poverty. It's well known how the family has fought and overcome Deann's battle with tongue cancer that was diagnosed in 2011.

What's not as apparent until you visit this community is how a town that's always bled red and black has come to bleed orange, too. They were all watching on December 12 when Watson, dressed in a red suit in tribute to his high school, went to New York and finished third in the voting for the Heisman Trophy.

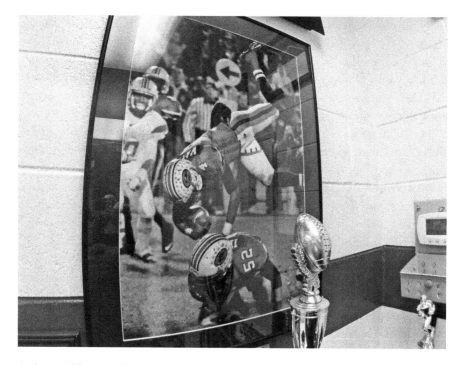

A picture of Deshaun Watson as a high school star hangs in the office of head coach Bruce Miller. *Larry Williams.*

108

"I've always been a Georgia fan," said David Presnell, the longtime groundskeeper for Gainesville High. "But since Deshaun has been at Clemson, I've been a Tiger fan. I guess I'll go back to pulling for Georgia when he leaves there."

It's remarkable how much the trajectories of Clemson and Georgia football were altered in 2010 when Billy Napier made a visit to Gainesville to check out a linebacker prospect named A.J. Johnson. At the time, Napier was Clemson's offensive coordinator. This was in May, and Gainesville's coaching staff was holding a draft for its yearly spring game. Perry, who would later become Watson's quarterbacks coach and offensive coordinator for the varsity, had the first pick and was laughed at by the other coaches when he chose an eighth-grade Watson over Johnson.

Napier told Perry he made the right choice. Watson's team ended up beating Johnson's in that game a year before Johnson went to Tennessee and put together a decorated college career. Even after Napier was fired months later, Clemson kept tabs on Watson and invited him to Dabo Swinney's camp in the summer of 2011 before Watson's sophomore season. Lyn Marsh, a Gainesville assistant coach and a lifelong Clemson fan, drove Watson up for that trip. Marsh remembers sitting in a golf cart with receivers coach Jeff Scott, who asked if anyone had offered. Marsh said no.

"Good," Scott said. "Because we want to be his first offer."

Marsh said his heart skipped a beat. Scott told him to keep his phone close by on the trip back to Gainesville. They were stopped at a gas station when the call came, and Marsh handed the phone to Watson.

"I could see his eyes, and they were beaming," Marsh said of Watson. "He had a big smile on his face."

Watson would not officially commit until seven months later, but Marsh said that offer was a crucial part of Watson eventually landing at Clemson. Chad Morris, who replaced Napier in 2011, made it his personal mission to keep the Tigers atop Watson's list even if it meant cutting into his summer vacations. For a while, Morris was the only college coach showing up to the gym for Watson's basketball games in the winter.

Before long, all the big names showed up. Nick Saban, Urban Meyer, Les Miles and an assortment of decorated coaches made their way to Gainesville to try to pry Watson from Clemson's grasp. And most of the residents of this community couldn't understand why the kid was seriously thinking about signing with the Tigers, a team that was a roller coaster under Tommy Bowden and even a few years early in Swinney's tenure.

Morris's visits to the basketball games would bring groans when the crowd saw the familiar guy walking in wearing the Clemson gear. "A lot of people here just didn't feel like Clemson was good enough," Marsh said. "There were a lot of people trying to talk him out of it, including some coaches."

For the longest time, the Bulldogs and Richt were a notable exception in the endless procession of coaches visiting Gainesville. Georgia was fighting Alabama hard for acclaimed quarterback Brice Ramsey, who was a year ahead of Watson and playing high school ball at Camden County High in South Georgia. The story goes that Georgia's coaches didn't want to start recruiting Watson until after Ramsey signed. But once that finally happened, in February 2013, it was too late. Ramsey, by the way, redshirted in 2013 and played in eight games in 2014 before becoming a punter in 2015 as a third-year sophomore.

The folks in Gainesville also can't shake the frustration of Georgia's indifference toward Watson's predecessor, Blake Sims. The Bulldogs' staff thought he'd be better as a defensive back, and Sims ended up guiding Alabama to an SEC title and College Football Playoff appearance in 2014 as a quarterback. Michael Perry, who played an integral role in cultivating

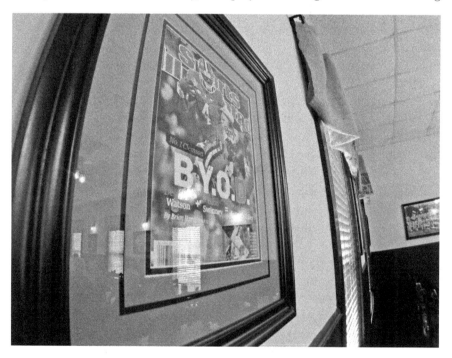

A picture of Deshaun Watson's *Sports Illustrated* cover hangs at Longstreet Café in Gainesville, Georgia. *Larry Williams.*

Watson's love of breaking down film, has been a Georgia fan for as long as he can remember. Perry's grandfather owned a Lincoln dealership in Gainesville that used to donate a car for Vince Dooley to drive when he was the Bulldogs' coach.

"Mark Richt would still be the coach at Georgia if they would have gotten Deshaun," Perry said. "Because he can run any offense. If they would have shown interest first, I think he would have ended up there. In the back of your mind, you always wonder, 'What if?'"

The frustration with Georgia's staff doesn't minimize the giddiness over seeing Watson guide Clemson to the extended No. 1 ranking, the undefeated record and the spot in the College Football Playoff. Outside Longstreet Café, a popular meat-and-three that Watson frequents when he's home, the billboard expressed support for Watson's Heisman chances in early December. Inside, a framed cover of the "BYOD" (Bring Your Own Defense) *Sports Illustrated* hung on the wall across the room from a framed No. 4 Red Elephants jersey.

As Watson became a college football celebrity in the fall of 2015, the city leaders in Gainesville began to organize a "Deshaun Watson Day" to properly recognize their hero. Watson's mother put an end to it, saying her son hadn't done anything yet. She said the town could honor him only after he received his college degree.

The day before Watson would lead the Tigers to the victory over North Carolina in the ACC title game, the high school organized an "Orange-out" with the majority of the student body and faculty wearing purple and orange. Where before it was almost unheard of to see anyone wearing stuff with the Tiger paw on it, now it's everywhere. No. 4 has successfully weaved the color orange into the red-and-black fabric of a community.

Said Presnell, the groundskeeper: "This has always been a Bulldog town, but now it's a Deshaun town."

TOMBSTONE COLD

It was the middle of December, and Clemson's media had their first opportunity to speak with Brent Venables since the matchup with Oklahoma was announced. The storyline was obvious: a year after facing the same Sooners program he spent thirteen years working for before coming to Clemson in 2012, Venables had to confront them *again*.

Two weeks before this post-practice gathering with the media, Venables stood at the pizza party and watched from the field with disbelief as Oklahoma's name appeared on the big screen opposite Clemson's. A year after closing the book on the Venables-faces-his-old-team storyline with a resounding 40–6 whipping of the Sooners, he was having to reopen the same book and talk about facing a bunch of guys who were basically like brothers to him when he was in Norman, Oklahoma.

But Venables's mind was on something else as he stood before a cluster of reporters inside Clemson's indoor practice facility. A TV guy asked him a predictable question about Oklahoma using last year's bowl result as motivation, and Venables went off in an unpredictable way.

Venables was peeved at articles he saw from Oklahoma chronicling the Sooners' disappointment at Clemson using that Russell Athletic Bowl victory as a "Tombstone Game." Since the Danny Ford era in the 1980s, the Tigers had made it a ritual to celebrate big road victories by planting a tombstone with the score and location of the game in their "Sod Cemetery." So commemorating the thirty-four-point destruction of Oklahoma was just part of the traditional routine. The Sooners took particular exception to it

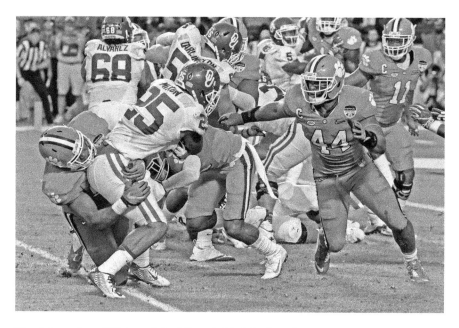

The defense slams Oklahoma's Joe Mixon behind the line of scrimmage.

in the days after the game, and then the storyline was revived after the 2015 national semifinal Orange Bowl showdown was announced. In the other bracket, Alabama would take on Michigan State.

"That's their way of making themselves feel good," Sooners receiver Durron Neal told reporters in Norman. "You have people on the Internet who will tell you about it. If that's what they want to do, that's what they do."

Center Ty Darlington, who spent the off-season using a picture from that game as his cellphone's wallpaper and the final score as his passcode, said he was "happy" the Tigers chose to celebrate the game in such a way.

"Apparently they do it for everybody and not just for us," he said. "If I told you I wasn't fired up after seeing the picture…I won't be trying to calm anyone down because of that, for sure."

No one asked Venables about Oklahoma's reaction to the tombstone. But he was going to tell everyone his thoughts on the matter anyway.

"We put a tombstone out there for any Top 25 team that we beat on the road, and have for years," he said, his voice rising. "We're not changing the tradition of what we do because we're worried about hurting somebody's feelings."

Venables also pointed out that the beating the year before could have been a lot worse. Clemson was up 40–0 after three quarters. Oklahoma's first and

only score came with 6:57 left in the game. "We took all of our starters out of the game well before the game was over because Coach Swinney has respect for the players and respect for the game. That's how he is…You start using ulterior motives to get you fired up, I don't believe in that. And I don't think they will either."

Privately, the entire team stewed over these words from Oklahoma's players—many of the same players they'd beaten into the dirt the previous December. Combine this with the Sooners opening as a three- to four-point favorite over the No. 1 team in the country, the only remaining undefeated team, and it was a galvanizing force for a group of players who seemed to feed off of outside negativity and the perception of being an underdog. A defense that dragged through the final few games of the regular season had a different look in its eye during on-campus bowl workouts. With rest, and now all-consuming motivation, Clemson seemed to possess the same edge that marked the days leading up to the October 3 showdown with Notre Dame.

When Clemson arrived in Fort Lauderdale the day after Christmas and began going through the typical press conference routines a day later, they were greeted with even more smack talk from the Sooners. Oklahoma had developed a loose, swaggering aura during a seven-game winning streak. It

Deshaun Watson leaps for yardage in the Orange Bowl.

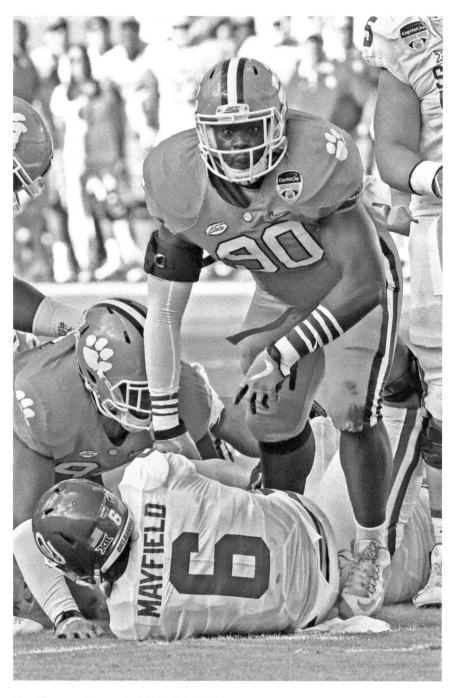

Shaq Lawson after a sack of Baker Mayfield.

seemed that the brash quotes were a part of their mojo and momentum, so they weren't going to stop it now—not even against the program that had dealt them such a humiliating defeat a year before.

"We like to talk a lot of trash during the games," said Oklahoma defensive lineman Charles Tapper. "We start talking early and don't stop. We know that with a lot of teams if we talk to them during the game, they'll sort of shut down." Tapper also said Clemson's offensive line looked "vanilla" and that he didn't see anything all that special out of freshman left tackle Mitch Hyatt. Running back Samaje Perine said there were areas of vulnerability on Clemson's defense and added that the 2014 defense was much faster and bigger.

Clemson's coaches were in virtual disbelief at the things Oklahoma's players were allowed to say. Dabo Swinney didn't say anything about the quotes publicly, but in team meetings he read them word by word to his players. He told them Oklahoma was trying to get under their skin. He warned them not to return fire, to handle themselves in a first-class way and treat the Sooners with respect until the game began.

Two days before the game, Swinney also had to tell his team he was sending three players home for positive drug tests. Receiver Deon Cain, kicker Ammon Lakip and tight end Jay Jay McCullough were gone. All three players had previous missteps, including one that sidelined Cain for the October 24 trouncing of Miami. Cain is from Tampa, and now on Clemson's second trip to his home state in two months he wasn't going to be available. When the news became official a day later, Swinney said it wasn't that big a deal as he sat before a room full of reporters during a previously scheduled press conference. He said basically the same thing he had said in July when peppered with questions about multiple players who had screwed up during the off-season.

"Why would it be a distraction?" he said. "It doesn't have anything—Jay Jay McCullough and Lakip and Deon don't have anything to do with Shaq Lawson and how he plays his game, doesn't have anything to do with the rest of those guys. It's not a distraction at all. It's a distraction for me because I have to answer questions about three guys that break our rules and I have to deal with it. But that comes with my job…Y'all may think it affects our team, but it doesn't. We had a great practice yesterday."

A few hours later, both teams gathered at a luncheon, and things got interesting afterward when a group of Tigers and Sooners players shared an elevator to the ground floor and then walked to their buses. An Oklahoma media outlet would report the next day that Lawson jumped onto Oklahoma's

team bus to talk trash, but here's how Lawson described it after the game: "We were at the luncheon, and Tapper kept talking and talking. We went to our bus and some of the players were coming over and talking through our windows, taking their shirts off and trying to start something. I got off our bus and went and stood in front of their bus, but that was it."

When game day came, the atmosphere on the field at Sun Life Stadium was charged almost from the moment the two teams took the field hours before kickoff. Lawson exchanged words with Tapper and had to be pulled away by former Tiger receiver Jacoby Ford. Cornerback Mackensie Alexander yapped with Oklahoma quarterback Baker Mayfield and a Sooners assistant coach, who told Alexander to get back to his side of the field. When the Tigers emerged from their locker room for their final warm-ups, a line of Clemson assistant coaches and graduate assistants separated the Tigers from the Sooners to ensure that a scuffle didn't break out. A referee had to shoo away a few Oklahoma players who ventured over to Clemson's side to talk some more.

The vibe in the Clemson locker room was one of total disrespect from those on the outside—and not just Oklahoma's players. Earlier in the day, the Tigers had sat and watched almost all of ESPN's pregame panel pick the Sooners. They turned the channel and saw a Fox Sports panel take Oklahoma with similar unanimity. For a team that had been fueled all year by people discrediting their accomplishments and their capabilities, this was yet more motivation to go out and make everyone else look silly.

Clemson's coaches went in thinking this Oklahoma team was better than last year's, largely because of how Mayfield had energized an offense and an entire team with his playmaking ability. In addition, the Sooners had a second dynamic running back to complement Perine in Joe Mixon. Add in those seven straight wins that followed a loss to Texas, and Oklahoma was widely regarded as the "hottest team in the country," and even the best team in the country. This, despite the fact that Clemson had remained No. 1 since the first College Football Playoff ranking back in October. This, despite the Tigers' 13-0 record. The Tigers seethed.

Oklahoma came in boasting remarkable balance. The Sooners averaged three hundred yards rushing per game over the seven-game winning streak, making them lethal in the downfield passing game because of all the focus on the run. Their defense was stingy against the run. But privately, Clemson's coaches believed Oklahoma wasn't accustomed to facing the physicality the Tigers would present on both sides of the ball. The Sooners were used to playing in the Big 12, a conference known for a finesse brand of offensive

football featuring four-receiver sets and smaller defenses geared to stop those personnel groupings.

If the absence of a proven playmaker (Cain) caused anxiety for Clemson fans going in, then the tension was compounded when Lawson went to the sideline early with a knee injury after a sack of Mayfield. When the defense went back out, Lawson remained on the sideline with a big towel draped over his neck. His day was done, and now trying to stop Oklahoma's offense seemed like a tremendously daunting task without one of the most indispensable players. Lawson's replacement, freshman Austin Bryant, had totaled a mere 146 snaps over the previous thirteen games.

Through one quarter, Oklahoma was up 7–3, and the Tigers hadn't put up much resistance. The Sooners coasted down the field on their first possession to take a 7–0 lead, and on the other side Deshaun Watson was looking shaky with his throws.

Down 7–3, the Tigers reached Oklahoma territory but stalled when tight end Jordan Leggett dropped a pass on third-and-four. The vibes were not good, and on the sideline, Swinney thought his team needed a shot of confidence and emotion—something to shake the big-stage jitters and make everyone loose again.

For months and months, every Wednesday the punt team had worked on a fake called "UConn." It was named for big freshman defensive tackle Christian Wilkins, who is from Connecticut. Wilkins is 315 pounds but is exceptionally athletic, showing the footwork of a 230-pounder. He was the perfect guy to sneak into a pass pattern against an unsuspecting defense.

That punter, by the way, was the same guy who thought it a good idea to fake a punt on fourth-and-long all by himself in the first half against North Carolina. The decision was a disaster, and Swinney made national headlines with the way he tore into Andy Teasdall on the sideline of that game.

If UConn didn't work, Swinney would have been ridiculed for entrusting such responsibility to a punter who had blown that opportunity twenty-six days before. He'd have been hammered for hatching a plan that involved a freshman defensive tackle running down a sideline and catching a pass. Swinney probably calculated all these factors before using his guts and taking the risk.

"When I first called it they looked at me like, 'What?'" Swinney said later. "I'm like, 'That's right. Let's go.'"

The play worked beautifully, Wilkins working over to the left side of the line and successfully going undetected as he released down the Clemson sideline. Teasdall patiently waited, acting as if he was about

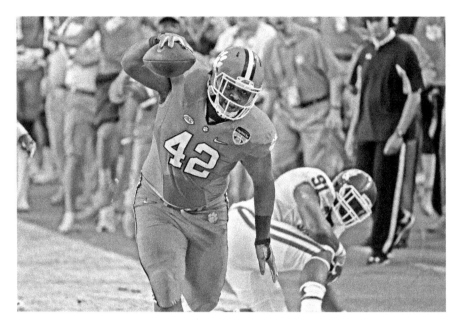

Christian Wilkins tiptoes down the sideline after a fake punt caught Oklahoma by surprise.

to execute a rugby-style punt to the right, before turning and heaving a rainbow to Wilkins.

"Pretty good throw," Wilkins said afterward. "Hung for a little bit. I was like, 'When is this thing going to drop? Oh my gosh. Any day now.'"

Wilkins hauled in the ball just as the Sooners converged and then tiptoed down the sideline before stepping out of bounds. Thirty-one-yard gain. Ball at the Oklahoma thirteen. Totally different vibe. Totally different game. Clemson would score to take a 10–7 lead, and from that point, everything seemed more manageable—even after the Tigers walked into the locker room down 17–16 at halftime.

"That fake punt has worked every time in practice," Venables would say later. "Dabo is a perpetuator of being positive. He's got a belief in everybody. He says it all the time: he's an over-believer. If that play doesn't validate that statement, nothing does."

Clemson would walk back onto the field in the second half and validate its status as the more physical team. When everyone outside the locker room was wondering how the Tigers would recover from Watson throwing an interception in the end zone to close the half, wondering how the defense would manage without Lawson, inside the locker room they were proceeding

with the utmost conviction. The message: take the ball and run it down Oklahoma's throat.

That's precisely what happened starting with an eleven-yard rush by Wayne Gallman, a five-yard rush by Gallman and a six-yard rush by Gallman. The redshirt sophomore had seven carries for thirty-nine yards in the first half as Watson did most of the damage on the ground. Co-coordinator Tony Elliott resolved to pound Gallman with the run, to get into the Sooners' legs by running plays at a breakneck tempo.

While the offense was putting together touchdown drives of seventy-five and seventy yards on two of its first three possessions of the second half, the defense was starting to take greater control of the line of scrimmage. While several games late in the season were marked by the defense wilting late, this time Venables's group seemed to grow more determined and focused as the game went on. And they were doing it without their best player, Lawson. The Tigers punished Oklahoma's three-headed backfield monster, sending Perine to the sideline with an ankle injury and Mixon to the sideline with a concussion. On a red-zone interception that basically ended it, linebacker Ben Boulware jumped and inadvertently knocked Mayfield woozy when his knee smashed into Mayfield's helmet.

Dabo Swinney, who called the fake punt.

When Gallman ran in from 4 yards out to make it 37–17 early in the fourth quarter, Swinney pumped his fists repeatedly on the sideline. There were still almost 11 minutes to play, but this one was over. And the way Clemson dragged the Sooners up and down the field during the second half had the same feel as their meeting a year earlier. The same Oklahoma offense that averaged 300 yards rushing over the previous seven games finished with 67 against the short-handed Tigers defense. Clemson piled up 312 rushing yards on fifty-eight carries as the Tigers surpassed 500 total yards for the tenth straight game. Once again, Swinney abused one of the game's great coaches, handing Bob Stoops a 54-point deficit in 120 minutes of football against Clemson.

After an emotionally stirring celebration on the field and then in the bowels of Sun Life Stadium, Clemson's locker room opened to the media and the Tigers got in the last laugh on the Sooners—and the last words.

"We're just little ol' Clemson," Swinney said in the locker room with more than a trace of sarcasm. "We've won seventeen in a row, but we're still the underdog. I can't answer why."

As he sat at his locker, defensive end Kevin Dodd was asked how much his team was motivated by the Sooners' chattiness during the week.

Ben Boulware soars in to make a tackle.

122

Ben Boulware and Austin Bryant with the stop of Baker Mayfield.

Deshaun Watson throws out oranges from the stage.

"Ain't the first time this has happened. Miami was talking trash, Florida State was doing the same thing. Everybody comes in thinking we're itty-bitty little boys and they're going to come out and maul us."

On the other side of the room, Elliott said he'd hoped to have some choice but respectful words with Tapper after the game. He was asked what he'd have said to the talkative defensive lineman if he had the chance.

"Just, 'Hey man, I have a tremendous amount of respect for your game.' Because he's an unbelievable player. And just go out and represent your university and represent your team with your play. And let's set an example for the young people that are getting into this game. Because there's too much in college athletics about me-me-me. It's still a team game. And he doesn't need to talk. He's a great player. He can let his play talk for him."

Kathleen Swinney stood outside the locker room after almost everyone else had filed out. She was waiting on her husband as he finished his media obligations and went in to shower. She said she felt like she'd hugged almost every orange-clad person in the stadium.

"I feel like I've been in every player's armpit," she said. "I'm sweaty and I stink. I'm disgusting."

It was a good kind of disgusting. The Tigers had another Oklahoma tombstone to prepare. And now they were taking their guts to Glendale to play for it all.

GUT PUNCH

The Tigers were off celebrating in the South Florida night at their team hotel when Alabama turned a playoff semifinal showdown with Michigan State into an absolute mauling in a 38–0 destruction.

The 37–17 dismantling of Oklahoma created a surreal vibe among Clemson fans and even those within the team. Now, the Crimson Tide's advancing to the final made everyone in orange pinch themselves even more. The Tigers were going to play for the national title. And they were going to play Alabama, which happened to be not just Dabo Swinney's alma mater but also the manifestation of everything Clemson people couldn't stand about how the college football hierarchy is perceived and covered by the media.

Dating from a soul-crushing defeat of Clemson to open the 2008 season, Nick Saban had built a dynasty in Tuscaloosa, Alabama. The Crimson Tide surpassed Urban Meyer's Florida juggernaut in 2009 by winning the Southeastern Conference and beating Texas for the BCS title. They won again in 2011 and then again in 2012. After watching Florida State and Ohio State win it all the previous two years, Saban's team was loaded and salivating for another championship in 2015. And Swinney's Clemson team was in its way.

The SEC won seven straight BCS titles from 2006 to 2012, and from that came a dominant perception among national media that the conference was far and away superior to everyone else. Fans of football-centric schools elsewhere, including Clemson, hated the alleged bias that came from the

The team gathers before the national title game.

SEC's run. They howled with delight when Florida State knocked off Auburn in the 2013 BCS title game, and they were positively giddy to see Ohio State tear through Alabama in the second half of the 2014 College Football Playoff semifinal.

When Mississippi went to Alabama and beat the Crimson Tide in the third week of the season, anti-SEC fans celebrated because it meant Saban's team was probably out of the chase for the playoff. Well, not so fast. Alabama responded to that defeat by smashing Georgia 38–10 in Athens and drilling just about everyone remaining on its schedule. It wasn't long before the Crimson Tide returned to the playoff conversation. Clemson fans stewed as Alabama didn't suffer a whole lot from the loss in the national rankings. The belief: Bama and teams from the SEC get mulligans when no one else does.

By the end of the season, though, it was evident to most neutral observers that the Crimson Tide was indeed the real deal. Alabama pulled away from Florida in the SEC title game and finished No. 2 in the final CFP ranking behind 14-0 Clemson. And the Crimson Tide was positively frightening in its destruction of Michigan State in the Cotton Bowl.

Alabama opened as a touchdown favorite, which provoked some chuckles from the Clemson side. Hey, the Tigers were an underdog against Oklahoma, and everyone saw how that turned out. Still, there was a feeling among the coaches and players as they sat down to dissect Alabama film that this was going to be a serious challenge. This was going to be the best team Clemson played, and it wasn't close.

The team locks arms and walks to the end zone in Glendale.

Brent Venables before the national championship.

Five days after the Orange Bowl victory, Clemson hosted its media day at Death Valley, and it attracted a who's who of national media. They descended on campus to learn more about the game's major storyline: Dabo facing the team he grew up cheering for, played for and worked for. He even turned down Saban in 2007 after Saban took over at Alabama. The narrative was delicious and irresistible, fitting perfectly into the Hollywood script of Swinney's life and this 2015 season.

Plenty of media came thinking Swinney might be nervous or guarded about the backdrop of the title game. They were mistaken. He spent an hour in front of the cameras and microphones casually weaving tales about his life, his appreciation for Bama legend Bear Bryant and just how ardently he pulled for the Crimson Tide when he was growing up in Pelham, Alabama.

"You leave the hospital, they stamp your birth certificate Alabama or Auburn. That's just how it is," Swinney said. Since his father, Ervil, was as big a Bama fan as they come, Swinney's birth certificate was stamped in crimson ink.

Swinney was asked whether he had any uncomfortable feelings about having to face his alma mater with everything at stake. He said he wouldn't want it any other way, facing Saban and the recent gold standard of college football. Swinney's longtime mentor, Woody McCorvey, said, "This is a matchup he has always wanted."

The matchup created significant emotional conflict for the people back in Pelham. Most of them were die-hard Alabama fans, but many of them also pulled for their favorite son as he built Clemson from an underachiever into a powerhouse. Now, they were faced with the wrenching choice of Alabama or Clemson. Some of them chose both, wearing a Clemson shirt and a Bama hat or vice versa.

When the Tigers and Crimson Tide arrived in Phoenix on Friday, three days before the game, the big question facing Clemson was whether star defensive end Shaq Lawson was going to be able to play. Lawson sat most of the game against Oklahoma after injuring his left knee. It was classified as a sprain of his MCL, and during the media day circus in Phoenix, he told reporters he was 60 percent healthy and that the pain was at an eight on a scale of one to ten. Making matters worse, the left knee was the knee he pushed off on while lined up on the right side of the defensive line. The defensive line performed just fine against Oklahoma in Lawson's absence, controlling the line of scrimmage and shutting down the Sooners' running game. But this was viewed as a more significant challenge against Alabama and Derrick Henry, who had won the Heisman Trophy the month before.

Deshaun Watson breaks free and scampers for yardage against Alabama.

Another source of stress for Clemson fans: cornerback Mackensie Alexander said he was recovering from an injury to his right hamstring suffered in the Orange Bowl. These two injuries, plus the absence of receiver Deon Cain to the suspension that was announced the day before the Orange Bowl, created some anxiousness in the days before the game.

Swinney was the picture of calm and, well, just himself as he sat with Saban for the final formal press conference the day before the game. As Saban greeted the proceedings with his typical glum persona, Swinney smiled and joked and gave off zero nervous vibes as he answered questions about the biggest moment of his professional life. A while later, after the two were whisked away to an interview with ESPN's Hannah Storm, Saban was asked to identify his biggest challenge as a coach. He pointed to Swinney and said, "People like this guy." Swinney's new-school approach to coaching, fueled by energy and feel-good vibes and an ability to galvanize elite talent, was a serious threat to the empire Saban built in his image.

University of Phoenix Stadium, located in a suburb of Phoenix, is a long way from South Carolina. The ticket prices were steep, ranging from $450 to $650. Many Clemson fans were financially strapped after going to the Orange Bowl and paying high dollar for that experience. Yet this trip to the

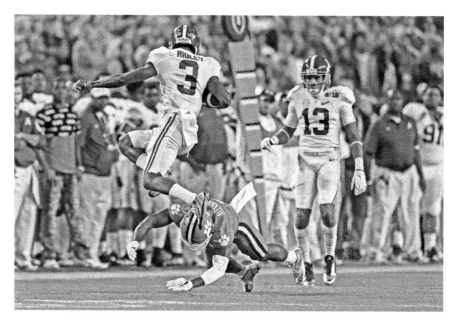

Mackensie Alexander stops Calvin Ridley for a short gain in the second quarter.

desert was basically mandatory for so many faithful who had watched their program wandering in the desert for decades after all that glory in the 1980s. This trip to Arizona was basically a pilgrimage.

Just about everyone picked Alabama in this game, and on the Crimson Tide's second possession, it was going about as predicted: with Henry running through a gaping hole on the right side of Clemson's defensive line and dashing fifty yards for a touchdown. This fit the conventional narrative of the Tigers not having the horses or the muscle to play Alabama's brand of grown-man football.

But the Tigers answered right away. First came a big kickoff return by Artavis Scott that put the ball at midfield. Then came a third-down pass interference penalty on Alabama, putting the ball in Crimson Tide territory. Then a third-down run by Deshaun Watson that gave the Tigers a first down at the thirty-one.

Watson was the biggest reason Clemson believed it had a chance to win this game. Similar quarterbacks had given Saban's defenses fits over the years, including Cam Newton, Johnny Manziel and Nick Marshall. Now Alabama had to stop the premier dual-threat weapon in college football, a player who could make a defense look silly even when the defense seemed

to do everything right. Saban had built his defense and his program on a thorough, meticulous platform called "The Process." But Watson was capable of messing it all up by the process of taking off and running. This was the matchup that made the game compelling, a big and strong and physical defense trying to account for a fleet-footed quarterback who could make plays with his arm and legs.

What was not a part of the pregame storyline was a former walk-on receiver named Hunter Renfrow completely outplaying a decorated defensive back named Minkah Fitzpatrick. Renfrow was regarded as a two-star high school prospect by Rivals.com, and Patrick was accorded the lofty five-star distinction. The stars didn't matter on the field, where Renfrow got by Fitzpatrick on a wheel route for a thirty-one-yard touchdown strike from Watson.

After Alabama missed a field goal, the offense went right back to work and Renfrow went right back to the end zone. On third-and-nine from the eleven, Watson found him on the back end for another touchdown. Again, Fitzpatrick was covering.

After one quarter, Clemson was up 14–7, and it was a different game. The Tigers had reeled off two touchdowns against a defense that was supposed to shut down this high-powered attack. And on the following

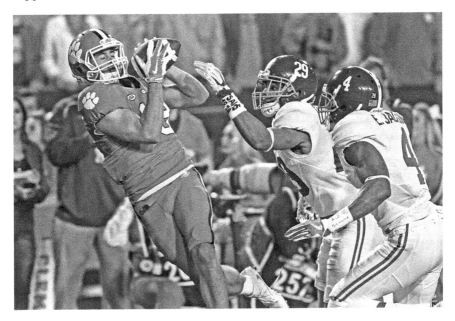

Hunter Renfrow with the touchdown catch that puts Clemson on the scoreboard.

drive, the defense began to froth thanks to end Kevin Dodd. Lawson wasn't himself but continued to play and battle. On the other end, Dodd played maybe the best game of his career while constantly getting by the right tackle and chasing quarterback Jake Coker. A sack by Dodd led to a punt, and Clemson had the ball at its seventeen with a chance to take a double-digit lead. On first down, seven yards on a keeper by Watson created an advantage situation on second down. The next play was intended for freshman Ray-Ray McCloud, who got behind his guy on the outside in man coverage. Watson threw for him, but he never saw safety Eddie Jackson lurking. Jackson made the easy interception, giving Alabama the ball at Clemson's forty-two. The Crimson Tide capitalized by motoring to the end zone for the game-tying score.

It was the first of several opportunities Clemson had to deliver a decisive blow and make the Crimson Tide desperate. Later, after Alabama went up 21–14 when tight end O.J. Howard got behind the defense for a fifty-three-yard touchdown, Clemson answered by producing a field goal and a touchdown on its next two possessions to take a 24–21 lead. The touchdown drive frazzled the Crimson Tide, who couldn't account for an offense that was making them cover just about every blade of grass on the field.

On third-and-goal from the one, going up the middle against the strength of Alabama's defense seemed an ominous proposition. Plenty of times before against stout defensive fronts, the Tigers chose to run outside with Watson or Wayne Gallman. But this was where Clemson was going to have to man up. This was where Clemson was going to show how much it had grown up since that pummeling at the hands of the Crimson Tide seven years earlier. Freshman fullback Garrett Williams entered the game and lined up in front of Gallman. The handoff went to Gallman, and he ran right up the middle, right behind Williams as Williams plowed into linebacker Reggie Ragland. Usually Ragland is the one pushing the other guy back, but this time Williams collided violently into the star linebacker and provided the push necessary for Gallman to get into the end zone.

Less than five minutes remained in the third quarter, and Clemson's defense was getting stronger. Henry ran for that big touchdown early, but the Tigers were making his life difficult by making contact with him behind the line of scrimmage. The Crimson Tide punted on back-to-back possessions, and Clemson moved into Alabama territory after both.

The Crimson Tide were reeling, and everyone in the building sensed an exquisite opportunity for Clemson to pounce. A touchdown would make it a two-score game and put the momentum squarely in the Tigers' favor.

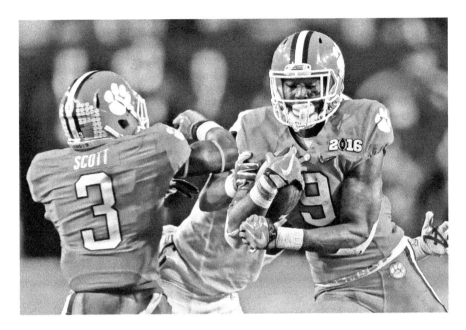

Wayne Gallman fights for yardage.

Clemson got nothing. A third-down sack of Watson produced a punt, and then a fumbled exchange between Watson and Gallman led to another.

Even after all that, Clemson was still in great shape because its defensive front was still giving Alabama major problems and creating negative plays. Cordrea Tankersley pulled down Henry on an outside run for a two-yard loss on second down, creating third-and-eleven from Alabama's forty-four. Coker dropped back to pass and faced instant pressure. He somehow managed to get off a high, arcing throw down the right sideline. The pressure made him release the ball early, so early that the intended receiver didn't even see it until the last instant. Guarded closely by T.J. Green, ArDarius Stewart spotted the ball and somehow came down with a twisting, thirty-eight-yard reception that put the ball at Clemson's eighteen. The Crimson Tide turned that into a field goal that tied the score at twenty-four.

Clemson's sideline was in a state of shock after watching the third-down conversion. On the other sideline, Saban sensed an opportunity to change the game. The Crimson Tide's staff had noticed Clemson's kickoff-return team cheating to one side to set up the blocking for a good return. Saban walked up to special teams coach Bobby Williams and said he was ready to execute an onside kick that would exploit the Tigers' overloaded alignment.

Williams walked up to offensive coordinator Lane Kiffin and told him to prepare the offense to go back onto the field.

Alabama's Marlon Humphrey lined up on the far right of the kickoff formation, across from Clemson's Trevion Thompson. As the ball was kicked, Humphrey flared out to the right—to all that open space Clemson's formation allowed. The ball was kicked so perfectly that a seasoned quarterback probably couldn't have thrown it any better. It sailed over Humphrey's outside shoulder, and he corralled it at the fifty-yard line. Swinney went ballistic, arguing that Thompson should have had a chance to catch the ball or call for a fair catch. But Thompson was so far away from the ball that it was hard to make the case he was trying to catch it.

Eleven days earlier, Swinney was the coach who made the game-changing call for a trick play when he audaciously called for his punter to throw the ball to a 315-pound freshman defensive tackle. This time, Saban showed some guts of his own. Saban broke into a rare smile on the sideline, and the Tide went up for good when Coker found Howard for a fifty-one-yard touchdown with 9:45 on the clock.

Clemson was still very much alive, though. The Tigers drove for a field goal that trimmed it to 31–27, and on the sideline, the defense prepared for a stop that would give the ball right back to Watson. The problem, however, was an issue that bubbled up on a regular basis during the season. The Tigers' troubles covering kickoffs weren't fatal in the first fourteen games because they were just better than almost everyone they played. On this stage, though, it was tremendously costly when Kenyan Drake reversed field and found an alley down the left sideline. His ninety-five-yard jaunt for a touchdown put the Tigers in a 38–27 hole with 7:31 on the clock.

Clemson was not done. Thanks largely to some courageous and determined running by Gallman, the Tigers marched right back down the field and found the end zone on a fifteen-yard pass from Watson to Scott. On this drive, Alabama's defense looked gassed after chasing Clemson up and down the field all night. The Tigers were starting to get into the legs of the big defenders. If not for the massive breakdowns on the previous two kickoffs, this might have been the game's defining and deciding turn. Instead, Swinney's team was playing from behind and in desperation mode.

Lawson played valiantly all game, but Alexander couldn't make it through the first half. He suffered an injury to his left hamstring in the second quarter and watched the second half from the sideline. He wasn't able to prevent the final dagger, an underneath throw to Howard on second-and-twelve that Howard turned into a sixty-three-yard dash down the

sideline to Clemson's fourteen. Corner Adrian Baker was in for Alexander, and Baker had established himself as a solid presence during the season. But Baker couldn't make the tackle behind the line of scrimmage, and it allowed Howard to run free. If Baker brought him down, Alabama would be facing third-and-long and it would be likely that Clemson would get the ball back needing a touchdown to go ahead. As it happened, the Crimson Tide burned more clock and gained another first down on a third-down run by Coker. They reached the end zone with 1:07 left on the clock, making it a twelve-point game.

There was still belief on the Clemson side, though. The Tigers went back down the field and scored with twelve seconds left to make it 45–40. Only when the onside kick sailed out of bounds did the Tigers acknowledge it was over.

Everyone inside Clemson's locker room fully expected to win this game, fully expected to make a mockery of the doubters who were skeptical of them once again. So there was no way to prepare for the shock and awfulness that came when the clock struck zero and the other guys were celebrating under the descending confetti.

A small knot of coaches and players remained for the ceremonial playing of the alma mater, arm in arm and rocking left to right as they tried to

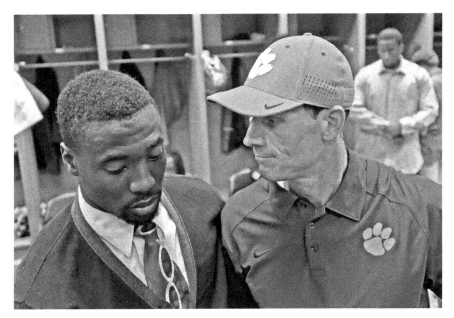

Brent Venables and Mackensie Alexander in the locker room.

process how this game slipped from their grasp. The fans above them were devastated, but they still gave the team an ovation as the Tigers walked to the tunnel and back to the locker room.

Clemson totaled forty points. It rolled up 550 yards. It successfully stifled Henry for much of the game. Despite all that, Swinney was presiding over a locker room full of crying coaches and players. He told them that the margin for error thins when you play football at the highest level, that his team just made a few too many mistakes to leave Glendale with a trophy.

Saban was celebrated for claiming his fourth national title in seven years at Alabama, a staggering accomplishment. But the college football world also gained an elevated appreciation for Clemson and how it goes about its business. The Tigers belonged on that field against the Crimson Tide. In fact, an argument could be made that the Tigers were the better team. They just couldn't take care of a few of the same details that hurt them during the regular season, and that's why they were 14-1 instead of 15-0.

Swinney had always told his players that the fun was in the winning, but the other side of that core belief is to keep your head held high in defeat. There was evidence of that even so soon after the Tigers' first loss since November 2014. While some of the players were frozen in their locker-room chairs well after it was over, still in uniform, others were able

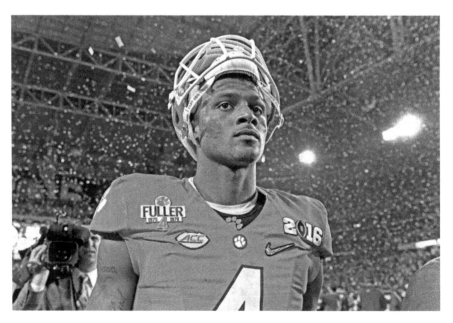

Deshaun Watson walks off the field.

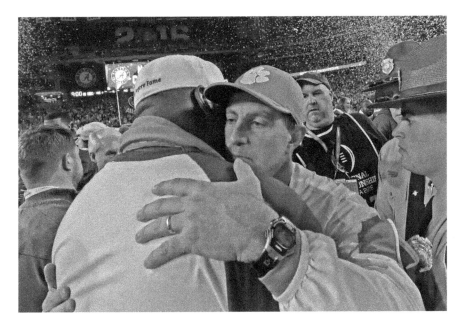

Dabo Swinney on the field after the game.

to look at the bigger picture and appreciate what this team and program had accomplished.

"I shed my tears already," said linebacker B.J. Goodson, a fifth-year senior who played his last game as a Tiger. "I'm just smiling now, I'll be honest with you. We had an awesome season, arguably the greatest in Clemson history. I couldn't be more proud. I'll definitely cherish this moment. To be a part of this moment, it's really a privilege. A lot of people take it for granted, but it's really a privilege."

After his postgame press conference, Swinney walked back into the locker room and gave hugs to former Tigers Stephone Anthony, Vic Beasley and Grady Jarrett.

"I'm sorry we didn't get it done," he said. "We'll be back."

Earlier, as Watson left the locker room for the press conference, he came across Beth Clements. The wife of school president Jim Clements gave him a hug and told him she loved him.

"I love you too," came the reply.

The way this one ended will sting for a long time, maybe until Clemson gets back to this stage and closes the deal. But the final blemish doesn't obscure the broader brilliance of a season that was defined by the Tigers showcasing their guts—all the way to the very end.

CLEMSON'S 2015 ACCOMPLISHMENTS

TEAM

- Finished second in the nation in the final Associated Press and *USA Today* polls—the second-highest final rankings in Clemson history and the best since 1981, when Clemson won the national championship.
- Ranked No. 1 in the nation for each of the six College Football Playoff Polls, the first school to rank No. 1 in every playoff poll during the season. Clemson was ranked No. 1 for each of the last five Associated Press polls and each of the last four *USA Today* polls heading into the bowl season.
- Became just the eighth FBS team to win fourteen games in a season and the second ACC team to do it (2013, Florida State). Alabama became the ninth by winning the national championship game.
- Set school record for wins in a season with fourteen, two more than any other Clemson team in the 120 years of Clemson football.
- Set school record with a seventeen-game winning streak over two years and won twenty-three of twenty-four. It is the longest winning streak in Clemson history.
- Had seven wins at home and seven wins away from home. Tied the school record for wins away from home set by the 1948 team, which had just four home games in its 11-0 season.
- Had three wins over teams ranked in the Top 10 of the final College Football Playoff poll, the only team in the nation that could make that claim.

- Posted a perfect 8-0 record in the ACC regular season, the first Clemson team to have eight ACC wins in a year. Clemson then won the ACC Championship with a 45–37 win over North Carolina in Charlotte.
- Defeated eight teams that finished the season with a winning record, most in a season in school history. Five of those wins came against teams with at least ten wins for the year. Clemson led the nation in wins over teams that had at least ten wins and ranked second in wins over teams with a winning record.
- Won four games against teams that were ranked in the Top 25 entering the game, including three in the Top 10. Tied school record in both areas. The 2011 team also had four Top 25 wins, and the 1981 team had three wins over Top 10 teams.
- Defeated rival South Carolina, won the ACC Championship and won a bowl game in the same year for the first time since 1988.
- Won a bowl game for the fourth straight year, the longest streak for the program since winning five in a row from 1986 to 1990.
- Seniors finished with a 46-8 record, the most wins in a four-year period by four games. The previous record was 42 wins by the class of 2014.
- Became the first school to beat Notre Dame and Oklahoma in the same season since 2004 when Southern California accomplished the feat.
- Gained wins over four of the top fifteen winningest programs in FBS history on a winning percentage basis (No. 1 Notre Dame, No. 5 Oklahoma, No. 11 Florida State, No. 15 Miami).
- Has won a bowl game against a team ranked in the Top 25 of at least one poll each of the last four years, the only FBS team to do that.
- From 2012 to 2015, won a bowl game against a coach with a national title on his résumé (Les Miles, Urban Myer and Bob Stoops twice). Clemson is the only program to do that in college football history.
- Had a perfect 7-0 record at home and has a 16-game home winning streak entering 2016. It is the second-longest active streak in the nation behind Florida State's 21.
- Seventeen different players were named first-, second- or third-team All-ACC by the ACC media and the coaches, most in school history. That includes nine different players who were named first-team All-ACC by at least one of the organizations.
- A record six different players (Deshaun Watson, Shaq Lawson, Jordan Leggett, Greg Huegel, Jayron Kearse and Mackensie Alexander) made a first-, second- or third-team All-America squad. It is the most players to make an All-America team in school history.

INDIVIDUAL

Deshaun Watson

- Finalist (one of three) for the Heisman Trophy, Clemson's first Heisman finalist.
- Davey O'Brien Award Winner
- Archie Griffin Award Winner
- Maxwell Award Finalist
- Walter Camp Player of the Year Award Finalist
- ACC Most Valuable Player by media and coaches
- ACC Championship Game MVP
- Most Valuable Offensive Player of Orange Bowl
- Consensus first-team All-American
- First-team All-ACC

Shaq Lawson

- Consensus first-team All-American
- Finalist for Vince Lombardi Award
- Finalist for Bronko Nagurski Award
- Finalist for Ted Hendricks Award
- First-team All-ACC

Jordan Leggett

- Finalist for John Mackey Award
- Second-team All-American by Walter Camp Foundation

Greg Huegel, PK

- Second-team All-American by *Sports Illustrated*
- First-team Freshman All-American by *USA Today*

CLEMSON'S 2015 ACCOMPLISHMENTS

Jayron Kearse

- First-team All-American by ESPN.com
- Second-team All-American by Associated Press
- Second-team All-American by CBS Sports and *Sports Illustrated*

Mackensie Alexander

- Semifinalist for Jim Thorpe Award
- Third-team All-American by Associated Press

COACHING HONORS

Head Coach Dabo Swinney

- Associated Press National Coach of the Year
- ESPN National Coach of the Year
- American Football Coaches Association National Coach of the Year
- Bear Bryant National Coach of the Year
- Walter Camp Foundation National Coach of the Year
- Sporting News National Coach of the Year
- Munger Award Winner (Maxwell Award Coach of the Year)
- ACC Coach of the Year by Media and Coaches

Brent Venables

- Finalist for Frank Broyles Award

ABOUT THE AUTHOR

Larry Williams has covered Clemson football on a daily basis since early 2004, when he joined the *Post and Courier* of Charleston, South Carolina. In 2008, he moved to Tigerillustrated.com, the most popular subscription-based Clemson site on the Internet. From 1999 to 2003, he worked as a sportswriter at the *Augusta Chronicle* in Georgia and covered college sports at Clemson, South Carolina and Georgia. He also covered the Super Bowl, the Final Four and the Masters. In 2007, he was named South Carolina Sportswriter of the Year by the National Sportscasters and Sportswriters Association. In 2011, he and Travis Haney co-authored the book *Classic Clashes of the Carolina-Clemson Football Rivalry: A State of Disunion*. He released *The Danny Ford Years at Clemson: Romping and Stomping* in 2012. He lives in the Clemson area with his wife and two daughters.

CPSIA information can be obtained
at www.ICGtesting.com
Printed in the USA
BVHW090031110619

550591BV00002B/18/P